"The Strunk and White o
—Louis Be

WRITING
THAT
WORKS

H TE
El SS

han
00
old!

Kenneth Roman and Joel Raphaelson

PRAISE FOR

Writing That Works, 3rd Edition

"This is the best all-purpose writing guide I've ever seen."

—LAWRENCE T. BABBIO, JR.
president and COO, Bell Atlantic Corporation

"Effective writing skills are invaluable in today's business world—but they're also in short supply. In this concise book, Kenneth Roman and Joel Raphaelson offer an abundance of practical tips for helping your written and oral communications get the results you want."

—WILLIAM C. STEERE, JR.
chairman and CEO, Pfizer, Inc.

"Clear, concise communications that make the right point will launch your career or business to new heights. This book will show you how."

—ROBERT SEELERT
chairman, Saatchi & Saatchi PLC

"In advertising, the challenge is to find the one simple, inspired thought that makes a consumer buy a product. This book helps all of us in the business world use the same discipline when we communicate our own thoughts to each other."

—PETER GEORGESCU
chairman emeritus, Young & Rubicam Inc.

Writing That Works

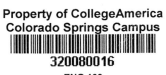

Writing That Works

Third Edition

How to communicate effectively in business:
e-mail
letters
memos
presentations
plans
reports
proposals
resumes
speeches

Kenneth Roman and Joel Raphaelson

HarperResource
An Imprint of HarperCollins*Publishers*

HarperCollins books may be purchased for educational, business, or sales promotional use. For information please write: Special Markets Department, HarperCollins Publishers Inc., 10 East 53rd Street, New York, NY 10022.

Designed by Ann Heilmeier and Elliott Beard

Library of Congress Cataloging-in-Publication Data
is available upon request.

ISBN 0-06-095643-7

07 08 09 ❖/RRD 20 19 18 17 16

If language is not correct,
then what is said is not what is meant;
If what is said is not what is meant,
Then what ought to be done remains undone.

—CONFUCIUS

Acknowledgments

With thanks to our new e-pals and others who contributed their wisdom and experience to this edition:

Seth Alpert, John Bernstein, Drayton Bird, Albie Collins, Jim Colosi, Scott Cutler, Ron Daniel, Terri Dial, Dio Dipasupil, Ron Eller, Qazi Fazal, Manny Fernandez, David Frieder, France Gingras, Greg Hackney, Harold Kahn, Mike Kelley, Peter Larson, Giancarlo Livraghi, Murray Low, Pete Lupo, Dudley Lyons, Toni Maloney, Louise McGinnes, Kent Mitchel, Jane O'Connell, Matthew Raphaelson, Charles Rashall, Chris Reid, Mike Reynolds, Mike Roberts, Karen Rosa, Randall Rothenberg, Angus Russell, Jason Spero, Bob Stearns, Michael Trent, David Vining, Ray Wareham, Bill Wright.

Contents

Preface **Why a Third Edition?**

The first edition of this book was written on a typewriter; we delivered a typed manuscript to the publisher. We wrote the second edition on computers and delivered a printed manuscript. This edition was written on computers and *e-mailed* to our editor—no manuscript, not even disks.

That illustrates one of the changes in the way people communicate that propelled us to undertake a thorough revision. E-mail has become so ubiquitous that we added a chapter and revised several others to take full account of its influence. Another change in recent years is the fading of the internal memo—displaced in many uses by e-mail, in others by the presentation "deck."

Our purpose, however, remains unchanged. We wrote the book to help those millions of nonprofessional writers who must use the written word to get results—in business, in government, in education, in the arts. That's still our goal.

Nor have we found any cause to abandon the *principles* we espouse. To the contrary, the speed and ease of e-mail and word processing serve as an invitation to sloppy writing. Replac-

ing paper with a PC screen doesn't change the need for clear, precise communication. And replacing a formal memo with a bullet-pointed presentation deck doesn't justify loose thinking.

In the second edition, we introduced some thoughts on how to avoid the pitfalls of sexist language. We have expanded those thoughts into a separate chapter on political correctness—and the extent to which it should or should not influence the way you write.

Throughout the book, we have freshened examples and sharpened points by practicing what we preach about editing. Coming from a world of thirty-second commercials has trained us to cut to the essence—and helped keep this book slim and our message accessible.

Nothing that follows is academic or theoretical. You will find advice you can act on, whenever you have to convert empty screen or blank paper into a letter, a memo, a report, a recommendation, a proposal, a speech, a resume. You'll get help from specific side-by-side examples of good writing versus bad.

"Generations ago the telephone killed the art of executive writing. Now it's poised for a comeback," reports *The Wall Street Journal*, noting that e-mail sends everyone to a keyboard. No wonder companies institute writing courses.

Effective writing is hard work even for the best writers (and even on a computer), but the principles are simple. They don't require unusual talent or special skills. They are easy to understand and easy to put into use. What you do need is a degree of determination—the perseverance to be sure you've said what you want to say. This book aims to help you do that with less difficulty and more confidence, and get the results you're looking for—from everything you write.

1 Writing That **Works**

"Too many of the communications I get are meaningless," observes a leading CEO. "They don't help me understand what action the writer wants me to take. They waste my time."

We could fill a dozen pages with complaints of this sort. "Unclear, poorly written, or confusing" is the verdict of vice presidents of two hundred major U.S. companies on a full third of the business writing they confront. New York's Commissioner of Education, frustrated that so many of the letters and memos passing through his office were "confusing" or "did not answer questions quickly enough," ordered his 250 top officials to take a course in writing. And so it goes. It adds up to a chorus of laments that so few people can put a thought into words that make it clear, state it precisely, and take no more of the reader's time than is called for.

Yet clarity, desirable as it is, is not the goal. The goal is effective communication—writing that *works*.

What does the reader need to know to comprehend your report and endorse its conclusions? To approve your plan, and pay for it? To respond swiftly to your e-mail? To send money for

your charity, your candidate, your product or service? To invite you to a job interview? To make the right business decision?

You're not likely to get the results you seek if your writing is murky, long-winded, bogged down by jargon, and topsy-turvy in its order of thought. Just as unproductive is what two Stanford professors, Jeffrey Pfeffer and Robert I. Sutton, call "smart talk." Writing in the *Harvard Business Review* in 1999, the professors identify smart talk as a major obstacle to taking action in business. A characteristic of smart talk is that it is unnecessarily complicated or abstract (or both). People seldom act on what they cannot understand. Good results are even less likely if you flood the reader with information that isn't organized to lead to an action or isn't relevant to a grasp of the subject.

Even the federal government is starting to recognize the benefits of simple, clear writing. The Securities and Exchange Commission inaugurated the plain-language movement by ordering mutual fund companies to rewrite their prospectuses. The Veterans Benefits Administration trained employees in its insurance division how to write more clearly, and the response rate to its letters increased—saving the agency $500,000 a year.

Companies are seeing how confusing communication ties up their service centers, and how clear communications makes them more efficient and competitive.

One executive suggests a discipline—putting down first what you want the reader to do, next the three most important things the reader needs to understand to take that action, *then* starting to write. When you're done, he suggests asking yourself whether if you were the reader, would you take action on the basis of what is written.

People who write well do well

To get action from busy people, your writing must cut through to the heart of the matter. It must require a minimum of time and effort on the reader's part. The importance of this increases with the importance of your reader. At any level, readers are likely to be swamped either with paperwork or a twenty-four-hour-a-day stream of e-mail, or both. Junior executives may feel obliged to plow through everything that comes their way. The president doesn't—and damned well won't.

A senior executive says this about a client:

> *His desk is usually absolutely clean, but I know that somewhere in that man's life there's a tremendous pile of paper. If I want him to read the memo himself, I'd better get right to the point and I'd better be clear, or he'll just pass it along to somebody else, with a testy little note asking for a translation.*

The better you write, the less time your boss must spend rewriting your stuff. If you are ambitious, it won't hurt to make life easier for people above you. Bad writing slows things down; good writing speeds them up.

The only way some people know you is through your writing. It can be your most frequent point of contact, or your *only* one, with people important to your career—major customers, senior clients, your own top management. To those women and men, your writing is you. It reveals how your mind works. Is it forceful or fatuous, deft or clumsy, crisp or soggy? Readers who don't know you judge you from the evidence in your writing.

Their judgment of you specifically includes the evidence you give them in the e-mail you dash off. It comes as a surprise to many people that readers of e-mail do not abandon

their standards just because they are looking at a screen rather than a piece of paper.

> *"Because it's just e-mail," says Christie Hefner, CEO of Play-boy Enterprises, "people think they don't have to be grammatical or spell things right or take the trouble to write well. It's very annoying."*

Slapdash comes across as slapdash, wordy as wordy, and poor spelling and grammar as signs of ignorance or sloppiness.

It is best to stick to standard English usage and to observe the conventions of spelling and punctuation. We advise this not out of academic fussiness but from observing how things are. If you write "it's" with an apostrophe to signify the possessive of "it" (wrong), instead of the contraction of "it is" (right), not all readers will detect your lapse. But those who do may be the ones who count. There still seems to be some correlation between literacy and seniority.

Important matters are usually examined in writing—either in a paper to be studied privately, or in a formal presentation. It isn't enough that you know all about your subject. You must make yourself clear to somebody who has only a fraction of your expertise. Above all, you must express your point of view persuasively. We have seen hundreds of papers that assert a point of view with energetic enthusiasm, but astonishingly few that make a persuasive case. Often enough the case itself is a good one. But the writer self-destructs in any or all of the ways we go into later on.

"It is an immutable law of business," said the former head of ITT, Harold Geneen, "that words are words, promises are promises, but only performance is reality." By itself, good writing is no guarantee of success. But words are more than

words, and poor performance can often be traced to poor communication. Your ability to write persuasively can help you get things done and arrive at your goal—today, this month, or during the decades of your career.

Making time to write well

Writing better does not mean writing *more*. There is paper enough in our lives now—despite the computer and e-mail— and precious little time to read it. This book suggests some of the ways that improving your writing can save time for other people. But what about *your* time? While you respect the time of others, you must also protect your own.

It takes time to write well. People are wrong when they say there are only twenty-four hours in a day, observes management guru Peter Drucker—there are actually only two, perhaps three, that you can use *productively,* and the difference between busy executives and effective ones is how they use that time. Effective means picking your spots, concentrating your energies on a major document or project or speech that will make a difference.

The biggest time waster is shuffling things from one pile to another while you drown in a sea of indecision. Effective executives try to handle paper only once—hard to do, but it works. They delete or respond to e-mail on the spot. They decide quickly whether to answer, file, or toss out. They respond to easy matters instantly—by return e-mail or through comments written directly on letters and memos and returned at once. Or send short handwritten notes (or e-notes) of direction, praise, or criticism.

Major papers, on the other hand, require study. Read them actively, get to the principal arguments, and decide what

must be done. Consider a "maturing file" for knotty problems. Many disappear if given time. Others call for more thought.

There is no rule that says you must answer or file everything that is sent to you. *Fortune* columnist Stewart Alsop became so swamped with the flood of e-mail that he first stopped responding to every message, then stopped reading them all. His reasoning:

> *The fact that someone sends me a message does not automatically impose an obligation on my part to respond. If that were true, then it would logically follow that I should allow strangers to rule my life. I don't like that idea. So I've started to delete messages without reading them first.*

This kind of discipline sets aside the time for the truly important as opposed to the merely urgent. It helps you clear the decks—at the office or at home—for the jobs that really matter. High among them will be major pieces that you write.

The rest of this book provides specific advice on skills and techniques that will help you put whatever time you spend on writing to good use. Implicit on every page is the idea—the *truth*—that the ultimate time-saver is effective communication.

2 Don't Mumble— and Other Principles of Effective Writing

When God wanted to stop the people from building the Tower of Babel, he did not smite them down with a thunderbolt. He said: ". . . let us go down, and there confound their language, that they may not understand one another's speech."

He could think of no surer way to keep the tower unbuilt than to garble communications. While the Lord confounded language on purpose, humans do it inadvertently—albeit with similar results. The suggestions in this chapter will help you avoid that fate for your own towers, whatever they may be.

Above all, *don't mumble*

Once you've decided what you want to say, come right out and say it. Mumblers command less attention than people who speak up. Keep in mind E. B. White's sobering injunction: "When you say something, make sure you have said it. The chances of your having said it are only fair."

Instead of this say this
It is generally desirable to communicate your thoughts in a forthright manner. Toning your point down and tiptoeing around it may, in many circumstances, tempt the reader to tune out and allow his mind to wander.	*Don't mumble.*

Here are some more suggestions:

1. Make the organization of your writing clear

Most people "write badly because they cannot think clearly," observed H. L. Mencken. The reason they cannot think clearly, he went on, is that "they lack the brains." We dare to assume that you, as a reader of this book, are brainy enough to think clearly. You know how to organize your thoughts into a coherent order. Now you must make that organization clear to the reader.

When you write anything longer than a few paragraphs, start by telling the reader where you are going.

> *The committee proposes that the company invest $1 million in a library.*

First you must know where you are going yourself. Make an outline of your major points, placing supporting details in their proper position. Then, in your paper, use your outline to signal

the major points for your reader. Underline and number each important section heading. This serves the same purpose as chapter titles in a book.

End with a summary. And keep in mind that a *summary* is not a *conclusion.* Your summary should introduce no new ideas; it should summarize, as briefly as possible, the most important points you have made.

If your paper comes to a conclusion—the point of your case—your summary should summarize that too, to fix the essentials of your message in your reader's mind.

Summary: Make an outline; use your outline to help your reader; number and underline section headings; summarize.

Note: Some lengthy documents *start* with a summary, often called "Executive Summary." The same principles apply.

2. Use short paragraphs, short sentences—and short words

Three major articles start at the top of the front page of every issue of *The Wall Street Journal.* The first paragraphs of these articles are never more than three sentences long. Many paragraphs contain only a single sentence.

The first sentences themselves are crisp and compact:

It all began to crumble the afternoon Mom's Best Cookies, Inc., fired Mom.

The cult of James Dean was fostered by his early death, and it didn't hurt his hometown any.

It's official—Wall Street is declaring war on sexism.

By contrast, here is an example of the kind of mumbling first sentence that confronts people in their office reading:

> *This provides the Argus, Mitchell & Dohn perspective on a consumers'-eye view of the current position and growth potential of Blake's Tea and Jones's Tea, the major entries of National Beverages in the English tea market.*

The Wall Street Journal is broadly read—beyond business and Wall Street. Readers and editors alike give much of the credit to its readability.

Journal editors have put into practice this simple principle: Short sentences and short paragraphs are easier to read than long ones. And easier to understand.

As for short *words*, you don't have to turn your back on the riches and subtleties of the English language. Nobody will excoriate you for using a long word whose precise meaning no shorter word duplicates. But prefer the short word to the long one that means the same thing:

Prefer this . . .	**. . . to this**
Now	*Currently*
Start	*Initiate*
Show	*Indicate*
Finish	*Finalize*
Speed up, move along	*Expedite*
Use	*Utilize*
Place, put	*Position*

Reliance on long words, which are often more abstract than common short ones, can be a sign that you have not worked out exactly what you want to say. If you have distilled your thinking to its essence, you will probably be able to express it in simple words.

Here is how George Bernard Shaw, in his days as a music critic, described his startled response to a new work: *"I did with my ears what I do with my eyes when I stare."* Once Shaw had figured out what his unusual reaction had been, he was able to describe it in words of one syllable.

Shakespeare expressed the deepest emotion in the simplest words. Says King Lear on the brutal murder of his beloved Fool: *"And my poor fool is hang'd. No, no, no life! Why should a dog, a horse, a rat, have life, and thou no breath at all? Thou'll come no more. Never, never, never, never!"*

The *Reader's Digest* once published an article on the power of short words. The last sentence pointed out, to the surprise of most readers, that no word in the eloquent three-page essay had more than one syllable.

3. Make your writing active—and personal

Good writers choose the active voice over the passive voice whenever possible—and it's possible most of the time. Active verbs add energy to your writing. That's why they're called *active*.

This simple practice also improves your writing by making it more personal, a human being talking rather than an institution. The passive voice hides who is speaking or taking action; the active voice reveals it.

Passive, impersonal	Active, personal
It is recommended	*We recommend*
He should be told	*Get Alice to tell him*
Personal sacrifices are being made, although the degree of participation is not absolutely identifiable.	*We see people making sacrifices. How many people? We can't say for sure.*

A lot of business writing mumbles along in the passive voice because high school English teachers told us not to start sentences with "I" without the first person singular (preferring "the cookies were eaten by me" to "I ate the cookies.") But there are plenty of good ways to substitute active for passive verbs.

Here is a typical passive construction—followed by active alternatives.

It is respectfully requested that you send a representative to our conference.

All of us here hope that you'll send a representative

Won't you please send a representative . . .

Somebody representing your company would add a lot . . .

Will you give serious thought to sending a representative?

You can see how much a representative from your company would contribute . . .

Without a representative from your company, our conference would be a fizzle . . .

You might protest that these alternatives don't all say quite the same thing. Exactly so. Yet another advantage of the active voice is that it tends to push you to decide precisely what you want to say, to be more specific.

4. Avoid vague adjectives and adverbs

A memo complains that the unfortunate outcome of some project "was reasonably unexpected." Reasonably? How unexpected is that? Or does the writer mean that a reasonable person would not have expected such an outcome at all? Depending on the intention, it would be a lot less vague to write:

Few of us expected this outcome.

Or,

Although I didn't expect this outcome, it didn't come as a complete surprise.

State your meaning precisely:

Vague	Precise
Very overspent	*Overspent by $10,000*
Slightly behind schedule	*One day late*

Some authorities advise weeding out adjectives and adverbs as a matter of principle. We don't. Adjectives and adverbs are parts of speech, often indispensable to precise expression. But we do distinguish between lazy ones and vigorous ones. The lazy ones are so overused in some contexts that they have become clichés:

Very good	*Great* success
Awfully nice	*Richly* deserved
Basically accurate	*Vitally* important

By contrast, vigorous adjectives and adverbs sharpen your point:

Instantly accepted	*Tiny* raise
Rudely turned down	*Moist* handshake
Short meeting	*Tiresome* speech
Crisp presentation	*Black* coffee
Baffling instructions	*Lucid* recommendation

Choose adjectives and adverbs that make your meaning more precise. Do not use them as mere exclamation points.

5. Use down-to-earth language

The pervasive use of professional jargon arises more out of fear than arrogance, hypothesizes Harvard paleontologist Dr. Stephan Jay Gould, author of nineteen books. "Most young scholars slip into this jargon because they are afraid that, if they don't, their mentors or the people who promote them won't think they are serious. I can't believe that anyone would *want* to write that way."

Avoid technical or business jargon. There is always a simple, down-to-earth word that says the same thing as the show-off fad word or vague abstraction. A leading offender in recent years is "proactive"—supposedly indicating the opposite of "reactive." What's wrong with "active," a real word?

Or, for more emphasis, "take the initiative."

Then there's "off-line," as in "Let's go off-line on that subject." What they mean is, "Let's discuss that separately, outside the meeting." "Reengineering" seems to be here to stay—in contexts that have nothing to do with engineers. Anything that's changed in any way is likely to be described as "reengineered." We might even have said, without raising eyebrows in trendy circles, that we "reengineered" this book. What we did say— that we expanded the book and updated it—may stir you less but tells you more.

The use of this kind of language became the target of an office game called Buzzword Bingo. The game is played in meeting rooms across the country. Players surreptitiously track the jargon spouted by their bosses, hoping to be the first in the room to fill out a bingo-like card listing the company's prevailing buzzwords. A discreet cough, rather than a shout of *Bingo!*, announces the winner.

We often urge people to write the way they talk. But developments like Buzzword Bingo indicate a perverse trend: More and more people in business seem to be talking the way they write. In the box on the next page, there are some words and phrases that might appear on Buzzword Bingo cards, followed by down-to-earth alternatives.

Buzzword	**Down-to-earth English**
To interface	*Discuss, meet, work with*
To impact	*To affect, to do to*
Modality	*Style, method*
Resource constrained	*Not enough people (or money)*
Incent	*Motivate*
Skill set	*Skills, abilities*
Solution set	*Solutions*
Resultful	*Effective, achieve results*
Meaningful	*Real, actual, tangible*
Judgmentally	*I think*
Net net	*Conclusion*
Suboptimal	*Less than ideal*
Push the envelope	*Test the limits*
Scope down (from microscope)	*Look at more closely*
Scope out (from telescope)	*Take a long view*
Workshopping	*Trying out, working on*

NOTE: Popular usage has confused *parameters* with *perimeter*. If you mean limits, say *limits*.

What's wrong with jargon like this becomes obvious when it comes at you in clusters, which is just how it tends to arrive:

Jargon	Down-to-earth English
It is believed that with the parameters that have been imposed by your management, a viable program may be hard to evolve. Net net: If our program is to impact the consumer to the optimum, meaningful interface with your management may be necessitated.	*We believe that the limits your management set may rule out an effective program. If we expect to reach our goal, we'd better ask your management to listen to our case.*

The kind of writing on the left is long-winded and heavy-handed. It is what E. B. White calls "the language of mutilation"—it mutilates your meaning. The language on the right is clear and direct. It illuminates your meaning.

6. Be specific

A fatal weakness in much business writing is the overuse of generalities. The writer has something specific in mind, but doesn't actually write it. The reader is left to guess. Friendly readers may guess sympathetically, but a neutral or skeptical reader will remain uninformed, unimpressed, and unpersuaded.

The first draft of a letter reporting to financial backers on a series of educational seminars in Wyoming said:

> *Our adult program was a great success. We attracted more stu-*
> *dents from more places than ever before.*

The reader, not knowing whether the increase in students
was one or a hundred and lacking any other specific informa-
tion, must take the generalized claim of success on faith.
When rewritten, the letter said:

> *Our enrollment doubled to 560. Students came from Wyoming*
> *and twenty-seven other states, and from Germany and Canada.*

There can now be no doubt about the success of the pro-
gram. The specifics speak for themselves.

7. Choose the right word

Know the precise meaning of every word you use. Here are
some words that many people confuse:

To **affect** something is
to have an influence on it:
The new program affects
only the clerical staff.

Effect can mean a result
(noun) or to bring about
(verb): *The effect of the new*
program on the morale of the
drivers will be zero; it effects
no change outside the clerical
staff.

It's is the contraction of
"it is." *It's vital that profits*
keep growing.

Its is the possessive form
of "it." No apostrophe. *Its*
profits grow year after year. A
bit of doggerel may help:
"Sin must prosper or it's
bored, while virtue is its
own reward."

i.e. *(id est)* means "that is": *He preferred short names; i.e., nothing longer than four letters.*

e.g. *(exempli gratia)* means "for example": *He gave all his products short names; e.g., Hit, Miss, Duck, Dive.*

Principal is the first in rank or importance: *Our principal problem is lack of cash flow.*

Principle is a guiding rule: *Our principle is to use our own money rather than to borrow.*

Imply means to suggest indirectly: *Her report implies that she will soon promote her assistant.*

Infer means to draw meaning out of something: *The assistant infers from her report that he will soon be promoted.*

Mitigate means to lessen in force or intensity: *She mitigated the bad news by giving everybody the afternoon off.*

Militate means to have force as evidence usually in a case against something: *The bad news militates against an early end to the raise freeze.*

Gratuitous means unasked for, excessive: *He had done his job to perfection for years. The advice from the newcomer was gratuitous.*

Grateful, gratitude. You know what these words mean. The point here is that they have no connection with *gratuitous.*

Foreword. Something that comes first. A preface.

Forward. Moving ahead, as in *forward, march!*

Appraise means to measure, to assess the value or nature of something: *The general appraised the enemy's strength before ordering the attack.*

Apprise means to inform in detail: *The chief of staff apprised the colonels of the general's appraisal of the situation.*

Fortunate means favored by good fortune—lucky.

Fortuitous means happening by chance, accidental. *Being seated next to his ex-wife was fortuitous—but hardly fortunate.*

Alternate (verb) means to go back and forth from one to another: *The coach alternated between passing plans and running plans.* As noun or adjective, it carries the same sense: *Mike and Jim are the coach's alternates; they play on alternate sets of downs.*

Alternative refers to a choice among two or more possibilities: *The coach faced the alternatives— go for the first down and possible victory, or punt to preserve the tie.*

Definite is most often used to mean positive, absolutely certain; *It is now definite that the factory will open on schedule.*

Definitive means complete and authoritative, determining once and for all: *It was the definitive design for a steel mill, a model for all others.*

Indifferent means that you don't care how it comes out: *The chairman, recognizing the triviality of the proposal, was indifferent.*

Disinterested is not the same as "uninterested." It means neutral and objective: *Amid the passions raging on both sides, only the chairman, recognizing the importance of the decision, managed to remain disinterested.*

Fulsome means excessive to the point of insincerity: *His fulsome praise was a transparent attempt at flattery.*

Full, abundant are in no way synonymous with fulsome. They carry their own familiar meanings.

Notable means worthy of note: *His research on Jack the Ripper is notable for its thoroughness.*

Notorious means famous in an unsavory way: *Jack the Ripper was perhaps the most notorious criminal of the nineteenth century.*

Into must be handled with caution. The headline writer wrote, murder suspects turn themselves into police—stunning as magic, but not what he meant. When the preposition belongs to the verb—"to turn in"—you can't use *into*.

In to is not synonymous with *into*. You go *into t*he house, or you go *in to find your wallet*. You look *into the subject* before you *hand your paper in to your boss*. The rules are too complicated to help. Be alert to the difference and use your ear.

When you confuse words like these, your reader may conclude that you don't know any better. Illiteracy does not breed respect.

8. Make it perfect

No typos, no misspellings, no errors in numbers or dates. If your writing is slipshod in any of these ways, however minor they may seem to you, a reader who spots your errors may justifiably question how much care and thought you have put into it.

Spelling is a special problem. Good spellers are an intolerant lot, and your reader could be among them. Whenever you are in doubt about how a word is spelled, look it up in the dictionary. If you are an incurably bad speller, make sure your drafts get checked by someone who isn't thus handicapped. Computer spell checkers can help, but they have serious shortcomings (as demonstrated poetically in Chapter 3).

9. Come to the point

Churchill could have mumbled that "the situation in regard to France is very serious." What he did say was, "The news from France is bad."

An executive mumbled in his report, "Capacity expansion driven by the sales growth encountered engineering issues which adversely impacted profits." What he was trying to say is, "Profits are off because engineering problems hurt our ability to increase production as fast as sales."

Take the time to boil down what you want to say, and express it confidently in simple, declarative sentences. Remem-

ber the man who apologized for writing such a long letter, explaining that he didn't have time to write a short one.

There are only 266 words in the Gettysburg Address. The shortest sentence in the New Testament may be the most moving: "Jesus wept."

10. Write simply and naturally—the way (we hope) you talk

One office worker meets another in the hall. "Ben," he says. "If you need more manuals, just ask for them." His ten-word message delivers his thought simply and directly. Anyone can understand. What more is there to say?

But let the same man *write* the message, and he pads it with lots of big words. Here's the way the written message actually appeared.

> *Should the supply of manuals sent you not be sufficient to meet your requirements, application should be made to this office for additional copies.*

A message needing ten words and eleven syllables is now twenty-four words with thirty-nine syllables, heavy reading, and sounds pompous.

Most Americans are taught that the written language and the spoken language are entirely different. They learn to write in a stiff, formal style and to steer clear of anything that sounds natural and colloquial.

Stiff	**Natural**
The reasons are fourfold	*There are four reasons*
Importantly	*The important point is*
Visitation	*Visit*

Notice how often somebody will say "It sounds just like her" in praise of some particularly effective writing. What you write should sound just like you talking when you're at your best—when your ideas flow swiftly and in good order, when your syntax is smooth, your vocabulary accurate, and afterward you think that you couldn't possibly have put things any better than you did.

A first step in achieving that effect is to use only those words and phrases and sentences that you might actually *say* to your reader if you were face-to-face. If you wouldn't say it, if it doesn't *sound* like you, why write it? (Some people, we've noted elsewhere, write the way they talk, but their talk has become impenetrable. They can safely ignore this section.)

The tone of your writing will vary as your readers vary. You would speak more formally meeting the President of the United States for the first time than to your uncle Max. For the same reason, a letter to the President would naturally be more formal than a letter to a relative. But it should still sound like you.

11. Strike out words you don't need

The song goes, "Softly, as in a morning sunrise"—and Ring Lardner explained that this was as opposed to a late afternoon or evening sunrise. Poetic license may be granted for a song, but not for expressions like those on the next page.

Don't write	Write
Advance plan	*Plan*
Take action	*Act*
Equally as	*Equally*
Hold a meeting	*Meet*
Study in depth	*Study*
New innovations	*Innovations*
Consensus of opinion	*Consensus*
At this point in time	*Now*
Until such time as	*Until*
In the majority of instances	*In most cases, usually*
On a local basis	*Locally*
Basically unaware of	*Did not know*
The overall plan	*The plan*
In the area of	*Roughly*
With regard to	*About*
In view of, on the basis of	*Because*
In the event of	*If*
For the purpose of, in order to	*To*
Despite the fact that	*Although*
Inasmuch as	*Since*

12. Use current standard English

Some years ago, a copywriter wrote this sentence in a draft of an advertisement to persuade more people to read the *New York Times*:

He always acted like he knew what he was talking about.

Musing over the use of "like" in place of "as though" or "as if," someone at the *Times* said: "Yes, I guess that use of 'like' will become standard in ten years or twenty, but I don't think the *New York Times* should pioneer in these matters."

The pioneers have multiplied since this book first came out, but we'd advise you on principle to be among the last to join them. New usage offends many ears; established usage offends nobody. Had the copywriter written, "He always acted as if he knew what he was talking about," it would have seemed both natural and literate.

The old rule is simple: Don't use "like" in any case where "as if" or "as though" would fit comfortably.

Nothing will call your literacy into question so promptly as using "I" for "me," or "she" for "her." Many people, though they have degrees from reputable colleges, make this illiterate mistake: "He asked both Helen and I to go to the convention." Try the pronoun alone. You would never write, "He asked I to go to the convention."

13. Don't write like a lawyer or a bureaucrat

Lawyers say that they have to write to each other in language like this:

BLANK Corporation, a corporation organized under the laws of the State of New South Wales, wishes to permit holders of its

Ordinary Shares who are resident in or nationals of the United States, its territories or possessions ("U.S. Holders") to participate in the Dividend Reinvestment Plan (the "DRP") on essentially the same terms as those available to its other shareholders ("Non-U.S. Holders"), and to provide the means by which holders of ADRs (as defined below) who are resident in or nationals of the United States, its territories or possessions ("U.S. Holders of ADRs") may indirectly participate, through the Depository, in the DRP. Toward this end, BLANK has adopted amendments to the DRP (as amended, the "Amended DRP") (a copy of which is attached hereto) to permit such participation.

Somewhat defensively, lawyers explain that such language is essential to precision in contracts and such. Perhaps, but we suspect that the same ideas could be expressed more briefly, more clearly, and without any treacherous increase in ambiguity:

BLANK Corporation wants to offer holders of its Ordinary Shares who are U.S. citizens or residents the opportunity to participate in its Dividend Reinvestment Plan (DRP) on the same basis as non–U.S. holders. This includes U.S. holders of ADRs (defined below) as well.

BLANK has amended the DRP to enable this participation, and a copy of the amended DRP is attached.

Whatever excuses lawyers may have, there are none for the business counterpart of this sort of writing, known as "bureaucratese." Among its symptoms are long sentences, abbreviations, clauses within clauses, and jargon.

If you find yourself writing like that, try putting down what you want to say the way you would say it to your read-

ers if you were talking to them face-to-face. Don't worry if the result is *too* casual. Once you've got the main idea down in plain English, you'll find it easy to adjust the tone of voice to the appropriate level of formality.

A good start in breaking out of bureaucratese is to banish from your writing unnecessary Latin. For example, "re," meaning "in the matter of," is never necessary outside the most formal legal documents. You don't need it in headings or titles any more than the Bible needs "re: Genesis."

14. Keep in mind what your reader doesn't know

Your reader seldom knows ahead of time where you are going or what you are trying to say. Never expect people to read your *mind* as well as your letter or paper. Take into account how much you can assume your reader knows—what background information, what facts, what technical terms.

Watch your abbreviations. Will they be an indecipherable code to some readers? Might they be ambiguous even to those in the know?

K is code for a thousand in the United States, M means million in England.

9/12 means September 12 here—December 9 over there.

If you must use abbreviations, define them the first time they appear in your paper. "The cost per thousand (CPM) is a figure that we will keep an eye on throughout this proposal."

15. Punctuate carefully

Proper punctuation functions like road signs, helping your reader to navigate your sentences. A left-out comma, or a comma in the wrong place, can confuse readers—or even change your meaning altogether. Here is a statement that most women will disagree with:

Woman without her man has no reason for living.

With a colon and a comma, the writer would get a different reaction:

Woman: without her, man has no reason for living.

A common mistake in business writing is to use quotation marks for emphasis: *This bolt provides "superior" tensile strength.* When the head of a large company put quotation marks around a word in an important paper, his administrative assistant asked him why he did that. He replied that it was to stress the truth of the point. The assistant asked whether it would stress the truth if he were to register at a hotel as John Durgin and "wife."

Most dictionaries offer lucid help on common problems of punctuation, such as the difference between a colon and a semicolon. You'll find brisk, useful advice either in the front or the back of the book.

16. Understate rather than overstate

Never exaggerate, unless you do so overtly to achieve an effect, and not to deceive. It is more persuasive to understate than to overstate. A single obvious exaggeration in an otherwise carefully written argument can arouse suspicion of your entire case.

It can be hard to resist the tendency to stretch the facts to support a strongly felt position. Or to serve up half-truths as camouflage for bad news. Or to take refuge in euphemisms. Whenever tempted, remind yourself that intelligent readers develop a nose for all such deceptive writing and are seldom taken in by it.

For the same reason, you should always round out numbers conservatively. Don't call 6.7 "nearly seven"—call it "over six and a half."

An obituary writer held in his file an envelope to be opened only when H. L. Mencken died. The message, from the famous writer himself: "Don't overdo it."

17. Write so that you cannot be misunderstood

It is not enough to write sentences and paragraphs that your reader can understand. Careful writers are ever alert to the many ways they might be *mis*understood.

A student paper began:

> *My mother has been heavily involved with every member of the California State Legislature.*

Some readers might have misunderstood the nature of the energetic mother's civic involvement.

Ambiguity often results from a single sentence carrying too much cargo. Breaking up your sentences can work wonders. Here is a statement from a report by the Nuclear Regulatory Commission:

> *It would be prudent to consider expeditiously the provision of instrumentation that would provide an unambiguous indication of the level of fluid in the reactor vessel..*

If you break that idea into two sentences, and follow other suggestions in this chapter, you might end up with something like this:

> *We should make up our minds quickly about getting better gauges. Good gauges would tell us exactly how much fluid is in the reactor vessel.*

18. Use plain English even on technical subjects

Annuities rank among the most complex financial products; one survey of investors found only 20 percent claimed a "good understanding" of them. Annuity documents were so impenetrable that the SEC moved to require prospectuses be written in "plain English" to make them more understandable to consumers. Their strategy, reports *The Wall Street Journal*: LOSE THE BIG WORDS.

A law clerk assigned to rewriting a variable annuity prospectus at Prudential Investments was given this direction: Write it as if you were sending it to someone you know—say, your grandparents.

The more technical the material, the less likely your reader will understand it unless you put it into the language we all speak. An exception is when both writer and reader practice the same technical specialty. An advertising campaign for New York Telephone points up the difference. In one of the advertisements, a company's telecommunications director talks technical language to other telecommunications specialists:

> *Given the strategic significance of our telecommunication infrastructure, our fault tolerance to local loop failure left a lot to be desired.*

In the same ad, the company's chief executive, talking to the rest of us, uses different language to make the same point:

If the network goes down, the company goes belly up.

What *Business Week* calls "technobabble" has aggravated just about everybody one way or another. "Plain English," says the magazine, "is a language unknown in most of the manuals that are supposed to help us use electronic products."

If you're writing to lay readers on a technical subject, test an early draft on a few of them. Finding out what's clear and what isn't can be valuable to you in editing. It can make the difference between success and failure in getting across what you want your reader to know, to understand, or to do.

Most murky writing is inadvertent, a sincere if doomed effort to communicate. Far worse is the deliberate attempt to say something that you know readers won't like in a way that you hope they won't understand. Let's call this the techno-euphemism.

- *A nurse who dropped a baby referred in her report to "the non-facile manipulation of a newborn."*

- *The uncomfortable writer of an Air Force news release, reporting on a test of a new missile, said that "approximately 70 seconds into the launch an anomaly occurred causing the range safety office to initiate the command destruct sequence." Hiding in there is the news that something went wrong with the missile and they had to blow it up.*

Bad news is not made better by being baffling as well as unwelcome. When you spit it out in plain English, readers still may not like it. But their displeasure won't be compounded by the suspicion that you're trying to slip one past them.

Consider the surprising bestselling business book *Who Moved My Cheese?*—an allegory about change by Spencer Johnson. It's a simple, almost corny, story about two small mice and two small humans who live in a maze where they find cheese, and how they respond when one day their cheese isn't where it used to be. Its appeal, says *Fortune,* is both its message—prepare for change, accept it, enjoy it—and its telling, in simple language.

Fortune cites a book on strategy by four management consultants:

> *In the specialist model, a company competes across geography by leveraging specialization advantages and intangible scale effects (i.e., leveraging the fixed costs of building intangible assets).*

It compares that sentence with this one from *Who Moved My Cheese?*—making almost the same point.

> *Every day the mice and the littlepeople spent time in the maze looking for their own special cheese.*

We're obviously not doing justice either to the consultants' text or the *Cheese* book, but the latter has really struck a chord in business circles. CEOs of important companies are buying and distributing thousands of copies. Why? It makes an important point—and does so in words that communicate. The author, says Harvard Business School professor John Kotter, "has written something that might actually influence people."

You might call that writing that *works.*

HOW'S YOUR STATUS ON AMBULATION?
And Other Things People Actually Say

A doctor asked a patient on the phone, *"How's your status on ambulation?"* What he wanted to know was, "Can you walk well enough to come to the office?"

Here are more examples, heard with our own ears, of people talking the way pretentious writers write. (This is *not* what we mean when we say, "Write the way you talk.")

Weather forecasters who say *tornadic activity* instead of tornadoes, *snow events* instead of snowstorms. On international flights, pilots ask passengers to *extinguish all smoking materials* instead of to put out their cigarettes. A pilot who said, "We're only five minutes late; considering the weather, I think that's *exemplatory* [*sic*]" instead of pretty good.

Here's a sampling of what we hear in business—over and over.

Resource constrained instead of *not enough people to do the job. Bake in the numbers* instead of *include. In the August time-frame* instead of *August. Tasked by the organization* instead of *assigned. The optics of the plan* instead of *how the plan will look. Double-click the point* instead of *emphasize. Drill down* instead of *analyze. Scope this out* instead of *check further. On a go-forward basis* instead of *in the future. Operationalized* its

goal, instead of *achieved*. *Aggressively ramp headcount* instead of *hiring a lot of people*.

Or *bandwidth*—as in *I don't have the bandwidth* (time) *for that meeting* or *He doesn't have the bandwidth* (ability) *for the job*.

Or this mouthful (we don't make these up): *The near-term cost of staying in the business plus the opportunity cost of suboptimal resource allocation,* instead of *The cost of staying in the business plus the cost of tying up money we might better spend elsewhere.*

This style of talk is generally heard among middle managers. It seldom comes from the CEO, who, having risen to the top, is less interested in impressing people than in clear communications—and getting things done.

Some terms that jarred originally have come through relentless usage to be accepted as more precise than their substitutes. *Delta from forecast,* instead of *change from what we predicted; What are the metrics?* instead of *How will we measure this?* This is a gray area. Just ask yourself whether you're being clear—or trying to impress.

3 "I Love My Computer"

The process of writing and editing on a computer, especially for anyone who started life on a typewriter, is so pleasurable that it elicits the kind of affection many people feel for a new car or some other precious possession. It's so fast and effortless to change a word, add a point, delete a sentence, move a paragraph. The practices we advocate in this book turn out to be easy, even fun.

Even those few still attached to their typewriters may soon find their clickety-clack days coming to an end. Author Tom Wolfe told an interviewer that his novel *A Man in Full* would be his last typewritten work, but not because he had fallen in love with a computer. He couldn't get his typewriter fixed any more.

In his excellent book *On Writing Well*, William Zinsser calls the PC "God's gift, or technology's gift, to good writing." But marvelous as these devices are, it's worth keeping in mind that they are machines and not magicians. They will not miraculously change a bad writer into a good one. They can even entrench a couple of the worst practices of bad writers, by making it so easy to send out half-baked material.

Most computers have dazzling charms for the writer. There's a good thesaurus, under Tools. There are templates for memos, business letters—anything you write repeatedly— that preset font, paper size, margins, as established by you. This saves a lot of time. Other tools allow you to do all sorts of useful things with page numbers, footnotes, inserts, section headings. You can get a word count in two seconds.

In the rest of this chapter we will run through the ways you can enlist your computer in your efforts to write well. And we'll put up a few warning signs to help you avoid the hazards that computers can throw in front of you.

How to Use Your Computer in Writing

There are as many ways to write on a computer as there are personal habits of writing. One writer likes to go back and correct after every paragraph or two, another roars through an entire draft without pause. No two people will find exactly the same set of practices suitable for their individual turns of mind. Your own proclivities will steer you toward what's best for you.

Longtime users, however, are in broad agreement on the merits of a number of procedures. Among them:

1. Write first, format later

Formatting is not writing. Playing with the details of the appearance of your paper can distract you from grappling with its content.

On the other hand, if you don't want your draft to be a shapeless jumble, it's a good idea to work from an outline—and

to do just enough formatting at the outset to make your structure visible.

The drafter of this chapter, for instance, formatted the headings and subheadings—all from his outline—as he typed the first rough version. This kept his thoughts in order as he went along. But going counter to his own advice, he also fiddled with indents and put the numbers and subheadings into boldface. They looked nice on the screen but wasted time and interrupted his train of thought.

2. Practice the Rule of More Than One

With computers, you have to be paranoid about saving your file. Never have just one copy of whatever you're working on; make sure there is a second copy—somewhere. Hard drives can crash, floppy disks are not forever. The authors save everything that is important on disks *and* print hard copies as well.

Get to know the AutoSave feature (found in Tools/Options), and set it to save your document at least every 15 minutes. Power surges, input errors, and other obliterators of your work are far from theoretical hazards.

We're also getting religion about running weekly virus checks. We let it go for a few months recently, and discovered forty-five viruses on our computer—and more than a hundred on our assistant's. Companies that used to catch a major virus every quarter now find one almost every day.

How often you make a hard copy of your rough draft depends on the length and importance of what you're writing—and on your own working methods. The more important the paper, the more likely you'll want to compare drafts or

refer back to earlier ones. While some programs make that possible directly on your computer screen, comparisons are often easier to read and to consider on side-by-side hard copies.

Date your drafts (using the Insert key). The authors would have been totally confused on chapters of this book without dates on every draft. Never ever circulate anything more than two pages long without numbered pages. It's maddeningly difficult to find a particular place in your document, or refer someone to it, unless the pages are numbered.

3. Give thought to your file names

Newer versions of word processing programs have made it possible to use descriptive titles (not limited to eight characters) for documents in your files. They also made it easy to be clever and get carried away.

As your disk fills up, it gets harder and harder to remember the cute title you gave that letter. And a complicated hunt through everything on your disk will have you longing for the good old days of physically riffling through a file drawer. You should develop a logical and easy-to-remember system for your file names. Professional writers think of their electronic file as a giant drawer with a small number of major folders, each divided into various subfolders, and so on.

For the current edition of this book, WTW3 was the primary folder; e-chapter and c-chapter two of the subfolders for new material on e-mail and computers respectively. In choosing your file names, prefer logic and simplicity to ingenuity. Your file should be a handy tool, not a puzzle or an amusement.

Cautions

"The word processor is an angel but it can't grant absolution," says freelance writer David Swift. Because edited work looks so perfect on the screen, it's easy to be deluded into thinking that it really is.

Proofread—and proofread again. Never send any document without checking everything with your own eyes. It's a good idea to do your proofreading on a hard copy rather than on your computer screen. We're not sure why, but when you face a piece of paper like the one your reader is going to see, you become more alert to errors.

Use the spell check program—with care. While it does a good job in highlighting words it *thinks* are misspelled, sometimes it tries to be too smart and automatically corrects words without asking. That can be dangerous, as one of us found in writing that Savill Gardens outside London had been introduced to him by his friend Stanley Pigott. It was "corrected" to *servile* gardens introduced by Stanley *piglet*. Computers are only human, one expert noted.

A cartoon showed this on a PC screen.

> *I have a spelling checker,*
> *It came with my PC;*
> *It plainly marks four my revue*
> *Mistakes I cannot sea.*
> *I've run this poem threw it,*
> *I'm sure you pleased too no,*
> *Its letter perfect in it's weigh,*
> *My checker tolled me sew.*

The grammar checker is even more fallible.

Stick to the point. In the cartoon strip *Shoe*, a character sitting in front of his PC replies to an onlooker who has asked what he's writing: "Nothing so far. But the computer makes writing a lot easier, I'll say that. With just a flick of the finger I can write reams of nothing. I call it streams of unconsciousness."

Resisting streams of unconsciousness may call for a conscious effort. Good writers heed their outlines and stick to the point.

Since even a loose first draft can look crisp and finished on your screen, you can fool yourself into mistaking it for a taut masterpiece. The illusion may be magnified by the satisfying whirrings and clickings of your printer as it seemingly certifies that what you've written is all set for publication. Careful writers try not to be fooled by appearances.

Be conservative in your choice of type fonts. The most readable fonts (type faces) are the ones used most often by well-edited magazines and newspapers. Choose fonts that resemble what you see in *Time* or *Sports Illustrated*, for example. For anything longer than a paragraph or two, ordinary roman faces are more readable than italics, and serif faces (like this text) are more readable than sans serif—**like this**. This isn't a matter of taste or opinion. It has been proved over and over in careful studies of readership around the world.

Whatever font you choose, stick with it throughout your document. You will not hurt the feelings of your computer if you don't use all its fonts in every paper. And you will save your readers' eyes.

Keep your fingers off the boldface and underline keys. **Boldface** and <u>underlining</u> are fine for headings but should be used only for **occasional** emphasis in text. The same goes for *italics*. When you emphasize *too many* words, the effect is **not**

what you intend. It may even be the *opposite*—when **everything** is emphasized, *nothing* is emphasized. And your page looks <u>messy</u>.

When you do want to emphasize a word or phrase, italics will do it most professionally. Well-edited magazines, newspapers, and books *always* prefer italics to boldface or underlines.

Forget about justifying type on the right margin. Justified type on the right looks good in books and magazines because the spacing between words is handled with a lot of care. Software programs tend to do the job crudely, leaving artificially large spaces between words or else jamming the words too close together.

Readers are accustomed to business papers with ragged right-hand margins. They look more natural, and are easier to read than papers that have forced both margins to line up. The narrower the measure, the worse the results.

Enough is enough. "Perfectionism is spelled p-a-r-a-l-y-s-i-s," said Churchill. In some hands the computer illustrates his point. Some people never stop editing. They never stop formatting. There is always one more change to try. So our final word of caution is don't be too cautious—let 'er rip! The computer is your liberator. Don't become its slave.

How much computer do you need for writing?

Whether it's your first computer or an upgrade, you need not be daunted by the hardware numbers or software options. Writers don't require a lot of electronic horsepower. Any computer sold today by a reputable manufacturer is more than powerful enough for word processing and e-mail. Major brands all give you more processing, disk space, and memory than writers know what to do with. (But get a quiet computer with a quiet fan.)

Which laptop you choose has implications for writing. Small, lightweight models, with slightly reduced keyboards and smaller displays, are a reasonable compromise if you go through a lot of airports. The slightly heavier, full-feature portables are better if you write or read large amounts of text, or use your laptop as a desktop or primary computer.

A few bucks extra on the monitor is a wise investment. The life span of a monitor is generally twice that of a desktop computer, and a desktop has twice the life span of a laptop. So it pays to get a monitor that's easy on your eyes. That means no smaller than seventeen inches, preferably nineteen inches if you have enough room on your desk or table. (New generation LCD monitors, which are clearer and flicker less than current

CRT models, permit you to use a screen that's a couple of inches smaller.)

Microsoft Word, the leading word processing system, is excellent and getting better all the time. Some experienced users have stopped automatically ordering each upgrade that comes along with new bells and whistles. They find earlier versions familiar, simpler, and adequate for their needs.

Printers have come a long way from the slow and noisy dot-matrix printers of not long ago. Ink-jet print quality is good. Laser printers are faster, with better print quality—and more expensive.

The big news is faster access to e-mail and the Internet, thanks to improved dial-up telephone modems. ISDN (Integrated Services Digital Network) or DSL (Digital Subscriber Lines) offer Internet connections up to twenty times faster than phone line connections, but at a price. Cable lines, connected through an Ethernet cable (built into most new PCs), are even faster.

Technology is moving so fast that more specific guidance would be outdated by the time this book appears. And it's not what you have—it's what you do with it that counts.

4 E-Mail—the Great Mailbox in the Sky

There was Santa on the stage of New York's Radio City Music Hall, reading Christmas letters and without making anything special of it, telling thousands of kids and grownups they can also reach him at *Santa.com*. And nobody blinked. (It was equally in character for him to stay in touch with the home office via mobile fax and cell phone.) We've moved from baby boomers to Generation X to *generation.com*.

Whether you count e-messages in billions or trillions, they're replacing a lot of conventional mail. E-mail does things that letters or phone calls cannot do as well or cannot do at all. It is easy, fast, simple—and cheap. It's perfect for quick answers, confirming plans, and short messages. It saves money on phone calls, messengers, and airfreight bills.

With e-mail, time zones go away. As does phone tag. If you do manage to connect on the phone, you are likely to interrupt whatever the other person is doing, even if it's just thinking. With e-mail, you send at your convenience, the receiver picks up at his or hers.

E-mail helps organizations stay connected and react quickly.

All interoffice communications should flow over e-mail, preaches Bill Gates, "so workers can act on news with reflex-like speed." He goes on to direct that meetings should not be used to present information: "It's more effective to use e-mail."

E-mail is changing rules of where we live and work. Instead of moving their families abroad, executives take up temporary residence in hotel rooms and become "virtual" expatriates with the aid of e-mail and cell phones. A *generation.com*–type cites the benefit of a permanent address: "Physical residence for people of my generation changes constantly, but my e-mail address will stay with me forever so people will always be able to communicate with me."

Warning: E-mail can be addictive and create problems of its own. Its emphasis on speed conflicts with matters that deserve thought and reflection. There are times when nothing beats conversation to solve a problem, or when courtesy calls for a nicely typed or handwritten letter. Newcomers on-line, giddy with their discovery, want to broadcast to everyone. Garrulous bores find a large unwilling audience. People with a natural tendency to hide barricade themselves behind walls of e-mail, sending notes to people four desks away. More people send more superfluous thoughts to more people, creating a growing glut in the system. Busy executives tune out, delete, or simply don't respond.

Time is the problem

The problem isn't so much writing e-mail as *receiving* it. But that in turn presents a writing problem: how to get your e-mail read by busy people, and acted on.

A seatmate on the plane from New York to Dallas, a consultant, reported nine hundred *unopened* e-mails on his computer in the past ten months. It wasn't laziness—he read and responded to e-mail for the better part of the flight. There was just so much of it that he had to be selective and ignore or delete all the obvious junk or apparent trivia that surrounded the important stuff.

Most executives receive fifty to one hundred or more e-messages a day; many receive up to four hundred. Assume half are easy to filter out and dismiss. Responding just to the important half, and initiating a couple of dozen messages, can take two to four hours a day. Every day. The flow never stops.

Planning time off for travel or vacation? Lots of luck! If you don't pick up your messages, they pile up relentlessly, making your return to the office that much harder. The merciless flow forces deluged recipients to steal family time or sacrifice sleep, even pull out computers during meetings in moments when their attention isn't required.

The time problem goes beyond e-mail. A Pitney Bowes survey shows the average U.S. office worker sends or receives 201 messages a day from telephones, e-mail, voice mail, postal mail, interoffice mail, fax, Post-its, telephone message slips, pagers, cell phones, messenger services, and express mail. Many of these put executives "on" all the time. What used to be getaway time no longer exists. Says labor economist Alan B. Krueger: "It's gotten far more difficult to measure where work ends and leisure begins."

Some comprehension of how, in all these ways, e-mail adds to the pressures of business today, is the starting point in writing it well.

How to Write Effective E-Mail

Business e-mail comes in several flavors. A large part consists of fast, terse notes—generally the shorter the better, as we will cover. In many cases, e-mail is replacing the paper memo or letter, but that doesn't change the factors that go into a good memo or letter.

Then there's a powerful new use of e-mail—collaborative work, a product of the Internet/PC era. This use reduces the need for collaborators to be in the same room (or building or city) to work together. It is characterized by a brief message with a document attached for comment, calling for the principles of both good e-notes and good business writing. The authors of this book collaborated on this new edition using e-mail between New York and Chicago, trading chapters and thoughts.

All these forms of business e-mail have a common goal: to move things along and not waste time. And all present the writer with the same problem: how to make sure your message gets read.

1. Make the subject heading clear—and compelling

All e-mail looks exactly the same in your In Box. There are no visual clues to what's important and what isn't—no airmail stamps, no fine-looking stationery, no impressively bulky envelopes, no familiar handwriting. The only clues are the identity of the sender and the nature of the subject.

You can't do much about the first—a recipient is either interested in hearing from you or is not. It helps, for instance, if you're the boss.

The element that is under your control is how you *identify your subject* in the heading, or title. The authors come from the

advertising business, and may be prejudiced on this point. But we know that the headline is the best read part of any ad, the element that gets people to read on. It's worth studying newspapers, particularly *The Wall Street Journal*, to understand what kinds of headlines convert scanners to readers.

You need a subject line that compels attention and gives a sense of what follows. It can be formal or informal, serious or colorful, bland or newsy. It cannot be absent.

Think of the consultant on the plane. Which e-mail will he read first—*Status of proposal* or *Winning client approval?* We know he won't open up e-mail without any title at all unless he knows the sender or has read everything else.

Busy executives filter their e-mail. Some use automatic filters that sort incoming messages into a priority system or just scan the index of senders and subjects. Terri Dial, who runs Wells Fargo in California, deletes a third of her messages without ever opening them (and, as a consequence, now pays more attention to her own subject lines so mail she sends gets read). She cautions against trying to get past this filtering by marking messages URGENT.

> *Too many senders use the urgent flag and now it's a bit like the little boy who cried wolf, only there are lots of little boys. Even if you use* URGENT *selectively, others don't. And remember that if you cry wolf too often, others will note it and your e-mail will get even shorter shrift.*

It is especially important that e-mail messages sent to a group quickly communicate the content so each recipient can determine if it is relevant to him or her. It is annoying to find after three paragraphs that the content is of no interest to you. Try to make clear at once which readers your message is for, e.g., *Schedule for rocket-launch team.*

Don't automatically keep old titles on replies that have nothing to do with the original subject, or on correspondence that goes back and forth endlessly with the same title, so it becomes impossible to distinguish one note from another. On the other hand, if you're adding to a message string that is already in progress and well established, don't change the title—even if it's no longer appropriate.

If you're sending several messages on unrelated topics, it's often better to send separate e-mails. It's no more work, and each message will be a lot easier to find and refer to.

While you cannot inflate your importance to the recipient, you can at least make clear who you are. E-mail addresses that are all numbers or signal your interests should show your name in the display in some way. (Among our fishing friends, we quickly identify <u>troutsmith@emailserver</u>, but can never remember who goes by <u>dryflier@emailserver</u>.) People learn quickly to delete junk mail. If a name doesn't ring a bell, out goes the message.

It's often useful to conclude with a signature that lists your phone, fax, and address. Title, too, if that helps. Many suggestions for this chapter came in e-mail signed:

> Regards,
> Scott Cutler
> VP Advanced Technology & Chief Technology Officer
> Compaq Computer Corporation, PC Products Group
> [telephone]

Most e-mail packages allow users to set up and automatically append signatures like this to outgoing messages.

2. Cut to the point

We mean that literally. <u>Cut</u>. Cut ruthlessly.

Not just to save the reader's time, but to get to the essence. E-mail is a different medium. Reading long memos on a PC screen is a pain; anything over one screen risks not being read (and is better sent as an attachment).

"I have never seen an e-mail message too short—most effective e-mails are short and very much to the point," says Manny Fernandez, Chairman of the Gartner Group.

Try to take out 50 percent of what you've written. You'll be amazed how your points leap out.

> *Someone asked Rodin how he could sculpt an elephant out of marble. It's easy, he responded, "You just chip away everything that isn't an elephant." Chip away everything that isn't your point.*

"Keep it short and sweet" is the first e-mail principle at HBO. Their executives are told that people want fast answers to simple questions. Make it brief, but make it complete—"meaty, concise, and to the point," as one of our best English teachers demanded.

As for abbreviations, although there is a whole library of clever ones for e-mail, we don't recommend them. Beyond FYI, most are new slang not familiar to enough people.

3. Avoid e-mail tag

Some e-mail can be too short, in the sense that it doesn't provide context. Responding without attaching or referring to the original message makes the reader search through Sent messages (if saved) to make sense of the reply.

"I'm available," for example, should be "I'm available to speak at your meeting on the fourteenth."

"Did you get my message regarding the meeting on the fourteenth? Can you come?" as opposed to "Did you get my message?"

It's forgetting to set context that causes so much e-mail tag. If the writer sends a message and the reader has to ask for clarification, the e-mail points of contact have been doubled. Be clear about the purpose of your message. What do you want the reader to do?

If you expect a response, you may want to set a deadline so that the response is not at the reader's inclination, which may be never.

4. Set the right tone of voice

E-mail is faceless and voiceless. The mood of the sender cannot be communicated by the inflection of a voice as on the telephone. E-messages are a different animal, subject to misinterpretation. Brief comments can come across as abrupt, terse questions as angry ("Where's the memo on . . . ?"). .

Some people use punctuation mark combinations, known as "smileys" or "emoticons," to convey the right tone. These take time to insert, are more used by teens than business, and not always understood.

The subject heading can be a good place to establish the tone you want.

Help! How do we reply?

Or,

Thanks a bunch, everybody!

Another place to suggest tone is the salutation. Some traditionalists can't bring themselves to abandon the time-honored *Dear Jean*. Others don't bother with salutations at all. But a greeting of some sort, especially if you're originating the correspondence, can help start things on the right foot. For example, *Hello Mr. Brown* is informal and friendly yet professional, and somehow seems more appropriate in these electronic times than *Dear Mr. Brown*. With colleagues and everyday associates, a simple *Hello, George*, or *Hi* can suffice. Or just use the first name.

A lot of e-mail ends abruptly—no signature of any kind. It just stops. Since the sender is identified at the beginning, goes the reasoning, why repeat his or her name at the end? But unless the tone of your message is absolutely clear, closing with *Thanks* or *Best wishes* or *Cheers* removes any doubt as to your state of mind.

In the past, people took the time to think, to consider what they wanted to say, before responding to a letter or memo. The possibility for instant response to e-mail—indeed the expectation of it in many cases—increases the danger of going off half-cocked.

Compose yourself, then compose your message. If you're writing an angry or irritable note, think twice before clicking *Send*. Seasoned e-mailers admit to sending hot messages and regretting they hadn't slept on them. Old-style memos and letters, which had to be typed, then read and signed, then put in the *Out* box, and then mailed, gave senders time to cool off and reconsider. Not so with e-mail—one click and it's as good as on your recipient's screen.

Some people protect themselves by handling correspondence off-line, downloading all messages, both incoming and

outgoing, before answering, so they can read and correct before sending. They find they tend to be hasty when the modem is on and the *Send* button is at the ready. Sometimes it's wise to respond, "Let me think about it overnight. I'll get back to you in the morning." In this way, the sender knows the e-mail has been received—and that the response, when it arrives, will be a thoughtful one.

E-Mail Etiquette

It seems like an oxymoron to couple this Victorian term with a New Age electronic medium. Nonetheless, there are old-fashioned virtues like courtesy and neatness that remain relevant in this modern medium.

In e-mail, one translation of courtesy is *Limit the number of copies*. The only thing easier than sending an e-message is adding people to the list receiving it. Copies are sent to far too many people—for the wrong reasons. To impress them. To cover yourself. To "interest" them. Don't broadcast supposedly "interesting" material to people unless you *know* their interests. It's the e-mail equivalent of junk mail.

If you want action, list only one name in the TO: field. With more than one name, it is not clear who has the responsibility to act and becomes likely that no one will take it on.

Reply All may be the most dangerous button on the screen. Count to ten before you unleash this plague on your victims.

Double-check to make sure your message goes only to the people you want it to go to. An evaluation of a partner in an accounting firm was inadvertently circulated among several thousand people. While the evaluation wasn't negative, its broadcast sure was embarrassing.

The following e-mail really happened:

From: Charlie Mix-up
Sent: Wednesday, May 26, 10:16 A.M.
To: L.A. Press List
Subject: FW: Press Summary, 5/26, and apologies for the 2,000 e-mails

Dear all,

For those of you who yesterday received 2,000 e-mails from me, I want to sincerely apologize. I had a problem in the configuration of my outlook and it forwarded by rule all the messages to the L.A. press summary list. I did not mean to cause you any trouble. It won't happen again.

Note: Do not reply to this message because it will go to all the members of the list.

Thanks and regards,

Charlie

Headed "E-Mail Fever," the following message to his staff from John Riccitiello, CEO of Electronic Arts in Silicon Valley, provides a heartfelt summary of ways to keep e-mail under control:

From: Riccitiello, John
Sent: Friday, January 21, 2000 2:31 P.M.
To: eaworld@eahq
Subject: E-mail fever

In the past few weeks, many EA folks have expressed their frustration over the huge quantity of e-mail we at EA seem to send each other. Many of us feel overwhelmed.

I would like to suggest a couple "rules" that might help stem the tide.

1: Do not copy unneeded persons on your e-mail. Send notes only to those that need to read it.

2: Avoid using the "Reply to All" button . . . unless there is really a good reason.

3: Do not join in the e-mail circus by adding your thoughts or short ideas to these never-ending e-mail threads that clog up our in boxes. Instead, when you see a monster e-mail thread starting, stop the flow and call a real face-to-face meeting to resolve the issue.

4: Do not use e-mail when a quick word over a cube wall will do the trick.

5: Avoid using broadcast e-mails unless absolutely required (yes, I see the irony in this).

6: Try to follow this rule . . . unless what you are sending (a) imparts new information to someone who needs it, or (b) agrees to a request, or (c) responds to a question or (d) asks a question or makes a request, do not send anything.

I know many of us get the shakes if we do not send an e-mail every few minutes, but take a deep breath and try to get over it. We'll all be happier.

John

Riccitiello says he has to send this reminder every six months or so.

Try not to make people scroll through a page or more of addressees before getting to the subject; they tend not to bother. One way to handle a long list is to give the group an alias name in the Address Book—we used *e-pals* for this book.

If you find yourself caught up in a series of copied messages which are of only peripheral interest to you, politely ask the author to take you off the copy list. When someone sends a batch of questions that will require too much time to answer in writing, ask the sender to set a telephone date for you to tackle them.

Since many executives are locked up in meetings or traveling and may not check their e-mail every day, sometimes it's wise to alert the recipient if the message is urgent. A brief voice mail message works here; actual contact is not needed. The general rule remains: e-mail or phone, but not both.

Another principle of etiquette, neatness, translates as *making it easy to read*—and is covered in the chapter with that title. However, one aspect of making it easy to read applies particularly to e-mail: how to handle attachments.

If the purpose of your message is to deliver an attachment, say so immediately: "Here is an attachment . . ." And go easy with the attachment. It's irritating to receive presentations with wild colors for text and background; they're hard or impossible to read, and take forever to download.

When sending large attachments or multiple files, your reader will appreciate it if you compress the files. (Check your PC manual or Help program to figure out how.) Compression conveniently groups files together and shortens download time.

This is especially relevant outside the United States. Remember that many people around the world pay per-character charges and telephone surcharges to receive your e-mail. And don't assume that the recipient has a high-speed modem, and easy access to the World Wide Web. If your e-mail contains an attached file or refers to a www address, your reader may not be able to get important information.

If you ever receive attachments with e-mail, you should definitely install a virus checker. One virus, Melissa, only caused embarrassment—it sent a list of porn sites from a target consumer's e-mail address book. Other viruses destroy files, wipe out data on a PC's hard drive, and even make it impossible to start up programs. The Chernobyl virus caused computer meltdowns around the world. Handle attachments with care—and back up anything important.

When NOT to e-mail

Most circumstances in which snail mail is preferable to e-mail are obvious: legal matters requiring signatures, invitations to formal events, fund-raising letters. Here are a couple that may be less obvious.

- If you have to change or cancel a meeting on short notice, a phone call or fax works better than e-mail. Don't count on people checking their In box two hours before the event.

- E-mail is not usually the best way to introduce yourself to someone. The executive contacted is probably flooded with messages and is not likely to open or read yours. It's easier to ignore or hit *Delete* than to say no thanks in person.

Nothing is private

When you seal a letter, place a stamp on it, and mail it, it does not become the property of the U.S. Postal Service. Your office e-mail, however, is the property of the company that pays for the e-mail system. Companies have the right to search their company mailboxes, and many do. Everybody uses office systems for personal messages. Just remember, it isn't private.

Some people describe e-mail as a high-tech watercooler, a place for off-color jokes, gossip, gripes about management. But at the watercooler, you have a pretty good idea of who's within listening range. Monica Lewinsky's e-comments, used in Clinton's impeachment trial, led *Fortune* to comment, "It's best not to E-mail anything you don't want to read on the front page of *The New York Times*."

Short of that, a good general principle is, never put anything personally negative in e-mail.

Given the litigating world in which we live, it isn't smart to send potentially distasteful material to colleagues on a corporate network. People have lost their jobs for sending jokes that they believed to be harmless but which offended someone who then complained.

E-mail records of exchanges that may have seemed innocent at the time have been credited as the U.S. Justice Department's "favorite weapon" in its antitrust case against Microsoft. They are often a plaintiff lawyer's dream come true. If you're on a corporate network, backup copies of your e-messages are archived. Lawyers go after system backup tapes to recover and subpoena supposedly deleted documents, and a system administrator can access anything that remains on your computer's hard drive.

The rule with paper files used to be, "If in doubt, toss it out." Not so easy with electronic files, where *Delete* doesn't delete. All it does is move material to another folder, like Recycle. You can delete again, but all that does is remove pointers to the message. The message itself still exists and can be found, unless you go another step and shred it by scrambling the codes. In any case, a record remains on another computer somewhere. Your odds of keeping something private are better if there is no written file.

The Internet is changing language. It has propelled the previously deliberate pace of language evolution to higher speeds. That was the general agreement at a meeting of the Modern Language Association. "A hotbed for change," said one linguistics professor.

This is a new medium and an opportunity to be creative—and an invitation to abuse. The Reagan-Bush White House created two hundred thousand electronic files; the Clinton office is creating six million files a year. E-mail is becoming more ubiquitous with wireless transmission and access from mobile phones and handheld computers. Beyond millions of new users coming on-line, e-mail voice recognition has arrived—with the terrifying prospect of people dictating stream-of-consciousness e-mails.

With such developments, the fight to stand out in the clutter can only intensify. It's unlikely that anyone will award you points for good e-writing. But if you get a reputation for being long-winded, fuzzy, or wasting people's time, your messages will tend to be glossed over, ignored, or deleted without being read.

Voice Mail and E-Mail

Business increasingly moves in an interconnected world of e-mail, cell phones, and voice mail. Voice mail can work together effectively with e-mail—to say an important e-mail is coming ("Watch for it"), to summarize its major points, to catch people who don't keep up with their e-mail every day.

You can't attach a document to voice mail or provide the same detail as in e-mail. E-mail is frequently the only written record of agreements. Many executives listen to voice mail in a car or on a cell phone, and can't take notes.

Voice mail is often abused, with messages that are too long and repetitive yet not complete. Names and phone numbers are either not given or not clear. The obligation to keep it short and sweet is even greater than with e-mail. You have a captive audience, unable to skip ahead, waiting impatiently for "the point."

Before you pick up the phone, assume it's likely the person you're calling will be out of the office or in a meeting, and you'll be into voice mail. Prepare yourself by thinking about what you want to say.

- Make it concise and to the point. No pleasantries necessary.

- Jot down a few bullet points that will make your message short and clear. (If it must be long, announce this—and the reason—at the start.)

- State your name and number clearly and slowly, especially the number. (This is the most violated principle, and its violation the most irritating, especially from people who want something done.)

Then hang up.

5 Memos and Letters That Get Things Done

"We don't write memos to each other!" is a declaration one often hears these days, as e-mail, phone calls, and meetings handle more and more business communication. On the other hand, we have yet to see an office without a printer or an executive without pencil and pad of paper.

The written word remains the best way to communicate in a variety of circumstances. Unlike a phone call, one can refer to a memo or a letter over and over. Unlike voice mail, you can scan a memo for the points important to you. You can study it, ponder it, pass it on to other people, or pull it up and print it out to refresh your memory days or years later. Unlike presentation decks, with their telegraphic and abbreviated points, memos and letters spell things out without relying on a spoken explanation.

As the writer, you can express your thoughts precisely, with every nuance just so. As the reader, you can consider a written matter when and where you choose and for as long a

time as you wish. Good memos and letters can solve prob-
lems, clarify issues, straighten out misunderstandings, raise
questions or answer them, spread the word, complain, mol-
lify, cheer up, and praise.

Here are some ways to assure that your memos and letters
succeed in their missions.

How to Write a Memo

Memos are letters to people within your organization, or to
people outside it with whom you work closely. You are writ-
ing to *colleagues;* write in a conversational style. But an infor-
mal tone of voice is no excuse for sloppy thinking or careless
expression. A confusing or ambiguous memo slows things
down or messes them up.

Whether sent by e-mail or on paper, good memos follow
similar formats.

1. Put a title on every memo

In e-mail memos your title is in your heading. On paper, it's
best to center your title in capital letters over your message.
It's easier for someone to spot there, thumbing through files
or briefcase, than tucked off to the left as "Re: Something or
Other," along with the list of addressees.

Your title should never be tricky or obscure. It should
identify—swiftly, and for all readers—what your memo is
about. A memo proposing an overdue raise for Tony
Andrino should not be titled LONG OVERDUE. Better
would be RAISE FOR TONY ANDRINO.

If you are responding to somebody else's memo, say so in your title:

FRANK OWEN'S MEMO ON HOG PRICES

GENDER-BLIND ADMISSIONS:
YOUR MAY 3 IDEAS

In memos on paper, don't worry about the length of your title. Say enough to identify your subject clearly:

RATIONALE FOR
GLOBAL CORPORATE ADVERTISING CAMPAIGN

Clear, simple titles attract the attention of interested parties, and focus their thoughts on your subject from the instant they start to read.

2. Address memos only to the person who must take action

Send copies to the people you merely want to keep informed.

From: Bill Durwin
To: Margaret Baker

copies: Cindy Lee
Sam Nasikawa
Bob Nieman

This says that Bill wants Margaret to *do* something, and the others just to know what's going on. If several people must do something, address the memo to all of them and make clear what each must do.

We prefer the full word "copies" to "cc," an anachronistic abbreviation for "carbon copies." And as an aside, we deplore the use of "blind" copies—copies sent behind the back of the addressee. As one executive puts it, "You can tell how political a person is by the number of blind copies he sends out."

List names of those receiving copies alphabetically. If you list them in order of importance, you often run into complications. Is the head of manufacturing more important than the head of research? Who comes first among four assistant deans?

Such problems evaporate if you put *all* names in alphabetical order, except when that would be ludicrous. It would be ludicrous, for example, in a memo to the Human Resources director with copies to two assistants and the president, to list the president alphabetically among the assistants. Put the president's name first; list the others alphabetically.

3. Make your structure obvious

Before you start to write, decide on structure. It will depend on the length, complexity, and nature of your subject. Any memo longer than half a page (or screen) requires a structure—*and the structure should be apparent to your reader.* Otherwise your memo will seem to ramble. Your reader will have a hard time remembering your points and how they hang together.

If what you want to say falls into conventional outline form—for instance, three main points, each supported by several examples, with a comment or two on each example—your outline will serve as your structure. A clear structure helps your reader to remember your points. It also makes your memo easy to refer to.

Some memos are actually complex reports or recommendations, running a half-dozen pages or more. In any such memo, start by outlining what you're going to cover.

Here's what is in the package:

- *4-page kickoff ad for the WSJ and FT*

- *2-page follow-up ads*

- *2 TV commercials*

- *Media Plan, including role of Internet*

- *Agency POV on what advertising will accomplish*

Recommendation:

- *Recommend that we commit $10M (media and production) to launch the campaign in mid-September.*

- *Need to commit to the media and begin production of television by July 26 in order to make mid-September launch.*

Do you agree?

Please let us know your comments and approval to proceed by Monday July 26.

Or write a brief covering memo and attach your report or plan as a separate document. This works well for major papers.

One useful structure is often overlooked: *a simple series of numbered points.* It has many advantages.

1. It suits your purpose exactly when you wish to make several loosely related observations on a single subject.

2. It eliminates the need to write connectives. When you're finished with one point, you plunge directly into the next.

3. It organizes your thoughts visually for your reader.

4. Your numbered sections can be as long or short as you wish. Some can be a single sentence, others two or more paragraphs. All that matters is that each number should indicate the start of a new and distinct thought.

5. Numbers make your memo easy to refer to.

4. End with a call to action

Say what you expect to happen as a result of your memo—exactly what must now be done, by whom, and by when. Be specific.

We need to move on the new products organization. I need your thoughts on candidates by end of business on Friday.

We need a new strategy for increasing attendance at the benefit before we send the invitation out.

If your memo replies to questions raised by somebody else, simply stop when you're finished. Don't waste your reader's time with such homilies as "I hope this answers your questions." Since it goes without saying that you hope you've answered them, go without saying it.

If your memo is a report, draw conclusions from what you saw or heard or found out. Specify how certain you feel about your conclusions. Some will be beyond question, others purely speculative. Tell your reader which are which.

5. Send handwritten notes

Brief memos written by hand save time and by their nature are more personal and direct. Praise and appreciation can be especially effective in handwriting:

> George:
> That's sensational news about Acme. Get some rest now—you deserve it!

> Susan:
> Your report is superb. I'll react to your recommendations as soon as I get back from Fargo.

Since handwriting is personal, make sure whatever you write *sounds* personal.

6. Be careful with humor—or anger

Don't try to be funny in memos unless you are positive that all your readers will get the joke. That includes people who may not be on your list but might see a copy of your memo. Avoid irony or sarcasm. Somebody will take it straight and get upset. People can brood for days over an innocently intended witticism.

As for anger, when you get angry in person, you leave nothing behind other than the memory of your behavior. When you put it in writing, you leave a *permanent record*. You may be sorry about that, after you cool down. Angry memos do have their place. A good rule is to *write* it when you're angry, but don't *send* it until the next day, when you have cooled off enough to reflect on the consequences. This is par-

ticularly important with e-mail, which is all too ready to indulge your spur-of-the-moment fury.

Should it be a memo at all? Even Procter & Gamble, which set the pace for the modern business memo, is reported to be deemphasizing it to meet the pace of the Internet age. An Italian proverb says: "Think much, speak little, write less." Sometimes the most efficient delivery of a message is still face-to-face. Just drop by the other person's office.

How to Write a Business Letter

There are times when only a letter will serve your purpose. A formal letter on a company letterhead carries an aura of importance that e-mail can't match and phone calls don't approach. Legal and financial matters call for precision and detail in a form that can be easily referred to. There is no substitute for a handwritten note of thanks, congratulations, or sympathy. Receiving and opening a first-class letter still is a pleasing ritual for some people. Here are ways to make sure you never let down any reader thus prepared for your message.

1. Get the name and address right

A misspelled name gets you off on the wrong foot. It suggests to the reader that you don't care, that you're a sloppy person. Check all names, no matter how much trouble it takes—on the envelope and in the letter, the names of individuals and of firms and organizations.

Use Mr. or Ms.—many people appreciate a touch of formality and nobody resents it. But leave it out rather than get it wrong when you aren't sure what gender you're writing to

and can't find out. Mickey, Terry, Gerry, Sandy, and many other names come on both girls and boys.

Check every detail. Mail addressed incorrectly seems slipshod at best, and at worst doesn't arrive. Always put a return address on the envelope. The stamp might fall off, or God knows what.

2. Think carefully about the salutation

"Dear _____ " is a convention we're stuck with, on paper if not in e-mail, in any sort of formal communication. Odd and antiquated though it may sound, efforts to avoid it seem artificial, self-conscious, and downright rude. We like the British custom of "tip and tail"—writing in the salutation as well as the signature by hand on a printed or typed letter. In less formal letters, a handwritten *Peter* or *Hi Peter* seems to work fine.

What comes after "Dear" is worth some thought. Use first names only when you're already on a first-name basis. Don't become anybody's pen pal by unilateral action. Use titles— Dr., Judge, Professor, Senator—when they apply.

An excellent but little-used alternative is to include both first and last names: "Dear Joan Larson." It is less formal than "Dear Ms. Larson," but doesn't presume personal acquaintance, as "Dear Joan" does. It's an attractive way to address somebody you have met but who may not remember you. Or somebody important and senior to you whom you know only slightly. Or the other way around. Oscar Hammerstein II, the great songwriter, wrote "Dear Joel Raphaelson" in a letter to Raphaelson, then in college, about a review of *South Pacific* in the college newspaper, and it seemed entirely appropriate, both courteous and cordial.

3. Consider beginning with a title

Many business letters are parts of a long-term correspondence between seller and customer, attorney and client, private firm and government bureau. In such cases, it's a good idea to follow the salutation with a title.

Dear George:

ACME LEGAL ACTION: SECOND PHASE

A title identifies the subject at a glance and is a blessing for anybody who ever has to dig out previous correspondence on it. Consider using a title even on one-time-only letters to strangers. Nothing else so quickly identifies the subject of your letter:

Dear American Express:

LOST CREDIT CARD—ACCOUNT #3729–051721

4. Make your first sentence work hard

Since titles on letters aren't standard practice, they may strike you as too abrupt or too impersonal for many situations. Then your first sentence has to perform the function of a title. Your reader wants to know at once what the letter is about.

Bill Smith brought to our attention your concern about Jane Jones's conversations with the XYZ bank.

There is no need for the written equivalent of small talk. The most courteous thing you can do is spare your reader the trouble of puzzling out what you're getting at.

Annoying small talk

Dear Classmate,

As you know, we had a wonderful fifteenth reunion last June. We can all be proud of the class gift we presented at that time. Now we are well into the first year of the end-of-the-century campaign.

Gratifying directness

Dear Classmate,

It's time to pull together our sixteenth annual gift to the university. You'll remember we gave a whopper at our fifteenth reunion—but the need goes on.

What about letters responding to inquiries or on a subject introduced in previous correspondence? Can you presume that the reader will know what your letter is about, having brought up the subject himself in an earlier letter?

Yes—up to a point. On the next page are two answers to a request for information.

Too windy

Dear Mr. Allen:

I am writing in response to your letter of June 24, in which you express an interest in the literature describing our line of herbicides, with particular reference to the control of dandelions in residential lawns. Unfortunately, we are all out of our pamphlets on this subject, but perhaps the following information will be of assistance.

Too abrupt

Dear Mr. Allen:

I'm sorry that we're out of the literature you asked for. Here's some information that may include what you need.

The letter on the right presumes too much. If Mr. Allen, who may write dozens of letters daily, doesn't happen to remember exactly what he wrote about to this particular firm, days or weeks ago, the first two sentences don't help him. He needs a speedy reminder of his inquiry—more direct than the first letter, less abrupt than the second.

Dear Mr. Allen:

We've run out of our literature on controlling dandelions. I'm sorry, and I'll send it as soon as a fresh supply gets here. Meanwhile, maybe this information will help.

The short first sentence reminds Mr. Allen of the subject and tells him the chief thing he needs to know. Always identify your subject in your first sentence.

5. Stop when you're through

Just as some letters take their time to wind up and get going, many slow down tediously before stopping. Avoid platitudes like these:

Please call if you have any questions.

I hope this answers your concern.

Please give this matter your careful consideration.

Unless you have something to say that is more than a formality, simply *stop*. If your last sentence says what your reader would assume or do anyway, as in the examples above, leave it out. Such stuff doesn't sound sincere or friendly. It sounds like what it is—routine formality. Your ending won't seem abrupt if your tone throughout the letter has been warm and personal.

If you want to add a personal touch, make sure that what you say *is* personal, and something you mean.

I've been reading about your heat wave and wonder how you're getting along.

George, customers like you make this business worthwhile.

6. Be specific about next steps

If you want your letter to lead to action, your last paragraph should make clear what you would like that action to be. Or, if you're taking the action yourself, what you're going to do:

Vague	**Specific**
We're hoping to hear from you soon.	*Please let us know your decision by August 1 so that we can meet your deadline.*
I'm looking forward to getting together with you to talk more.	*Are you free for lunch on Friday, July 17? I'll call that morning to confirm.*

7. Use an appropriate sign-off

Gene Shalit, the *Today* show movie critic, signs his letters "Thine." It's a personal trademark, like his bushy hairstyle. In general, though, your sign-off isn't the place to assert individuality. Keep it conventional and appropriate to your tone.

"Yours truly" benefits from a lack of any specific silly meaning. It is as rooted in convention as "Dear George," and useful for that reason.

"Sincerely" and "Sincerely yours" are all right if you don't mind proclaiming something your reader should take for granted.

So many people have latched on to "Cordially" that we have become numb to its mindless assertion of hearty friendship. Just don't use it on noncordial letters: "We've turned your case over to our attorneys. Cordially. . . "

"Regards," "Best wishes," "All the best" are more personal than the others and less formal, but not appropriate if you don't know your reader.

And there isn't anything wrong with simply signing your name after your last sentence.

How to Handle Some Common Kinds of Letters

Letters that ask for something

Say what you want, right away. Don't start by explaining *why* you want it. Your reader won't be interested in your reasons before you reveal what you're asking for.

> *Dear Mr. Sullivan:*
>
> | *We are a new electronics firm and we need to* | **Our problem** |
> | *set up a department to do some basic research.* | |
> | *Accordingly it occurred to our president,* | **Our thinking** |
> | *Mr. Gene Schultz, that it would be a good* | |
> | *idea if we found out how some giant research* | **Still hasn't said** |
> | *departments such as the Bell Laboratories were* | **what we want** |
> | *organized in the early days.* | |

Don't *start* by expressing your appreciation.

> *Dear Mr. Sullivan:*
>
> *I would greatly appreciate your help on a matter in which the Bell Laboratories may be uniquely well informed.*

Write that letter like this:

> *Dear Mr. Sullivan:*
>
> | *Do you have any literature that spells out how* | **Says what we** |
> | *the Bell Laboratories organized in its formative* | **want, and that** |
> | *days? If so, would you send it to me and* | **we'll pay** |
> | *bill me?* | |

We're a small Internet firm selling office | **Explains why**
equipment, and your early experience might help
us figure out the best way to get going. | **Thanks!**
Your help would be invaluable to us.

That's the correct order for letters of inquiry; *first*, what you want; *second*, who you are and why you want it; *third*, an expression of appreciation for favors to come. If you're asking for routine information—a copy of a published speech, records on your bank account, a price list—you can leave out the reason you want it and shorten your thanks.

How to say no

No, we don't have a job for you. No, we won't give you more credit. No, we don't agree that it was our fault and that we owe you a refund. No, we can't get your order to you in time for Christmas. Alas, we can't publish your story. Sorry, we regret we can't contribute to your charity.

Turning somebody down in writing may seem easier than doing it in person, but in some ways it's a lot harder. It is less personal and more permanent.

Readers can't see the expression on your face. Nor can they hear the tone of your voice. Nor can they ask questions on the spot about things that puzzle them or that they take issue with.

Your letter has to compensate for those disadvantages:

- It must be as *clear* as you would be in person.

- It must be as *tactful* and *understanding* as you would be in person. Pay close attention to your tone.

- You must anticipate your reader's questions and objections and do your best to answer them.

Put everything in your letter to this test: *Would you say it and would you say it in that way, if you were face-to-face with your reader?*

"We regret to inform you that . . ." is the standard opening of millions of "no" letters. It is hard to imagine anybody ever *saying*, "I regret to inform you that. . . ." You'd say "I know how disappointed you're going to be, but there just isn't any way I can do that" or "No, I don't think that will be possible—but how about this as an alternative?"

Let's say you're the manager of a store that sells refrigerators. After using your top-of-the-line model for almost three years, a customer has reported that it conked out on a hot weekend when he was away, and that he returned to find all his food spoiled.

He wants you to replace the refrigerator with a new one, free, and to charge nothing for the service call that put his refrigerator back into commission—only temporarily, he fears.

Here is how some people would respond:

Dear Mr. Traggert:

I regret to inform you that we are unable to accommodate your request for a new refrigerator. Our repairman reports that the trouble was minor and is unlikely to recur.	**An institutional thumbs down**
At the time of purchase, you were offered a three-year service contract. Had you accepted it, our service call would have cost you nothing additional.	**What a dope you were!**
But since you did not accept it, we are required to charge you for the service.	**Our hands are tied**
I sincerely regret any inconvenience this episode may have caused you and hope that you	**Boy, do we sound sincere**

will now get many years of satisfactory
service out of your Model 6034-Y.
 Yours truly,

A turndown like this, with its chill, corporate tone, is all but guaranteed to lose a customer for your store.

If you were to hear Mr. Traggert's story at a dinner party, you wouldn't say "That episode may have been inconvenient for you." You would respond spontaneously with something like "That's *awful*—what a way to come home from a weekend!" Why not start your letter in the same human way?

Dear Mr. Traggert:

How terrible for you to come home from a
weekend and find all the food in your
refrigerator spoiled. I can imagine how you
must have felt.

The reader now knows that at least you appreciate his predicament. You might continue in the same vein:

I quite agree that any refrigerator—and particularly a deluxe model such as yours—should give you trouble-free service for a lot longer than three years.	**Agreeing is better than arguing**
However, no manufacturer's system of quality control is perfect—which is why we advise our customers to invest in a service contract.	**Puts problem in perspective**
If I were to charge you nothing for your service call, you would, in effect, be getting the benefits of a service contract without having paid for it.	**Appeals to reader's sense of fairness. Note use of first person.**

In considering your request for us to replace your refrigerator, I have talked to the repairman who fixed it. He assures me that there is nothing fundamentally wrong—the problem was caused by a freak failure of a common bolt, which he has never seen happen before. He feels it is most unlikely to recur: "A million to one against it," he said.	**Seriously considers reader's request, gives full reasons for turning it down**
I don't think a new refrigerator would be any more likely to give you the years of service you have every right to expect.	**Even the turndown is sympathetic**
But should you have further trouble, I hope you will get in touch with me at once. *Yours truly,*	**Leaves door open**

In this letter, the author shows a personal interest in the customer's situation. He treats the demands as reasonable, and takes the trouble to explain why he is turning them down. He leaves channels of communication open—just in case. In short, his letter sounds as though he cares.

Never say no in anger—no matter how angry the other party may be. You are in the position of power. Control yourself. Always appreciate the feelings of the person you are turning down.

Never belittle anybody—never make a request or a complaint sound foolish or unreasonable. Always show consideration for points of view other than your own.

Never say no casually, in an offhand manner. Always take the trouble to explain your reasons.

All of this applies just as forcefully to a *form* letter. Do everything you can to make it sound as little like a form letter as possible.

The admissions staff at Dartmouth College has to turn down

thousands of applicants to every freshman class. A form letter
gets straight to the point that "we cannot offer you admission to
the class of 2004 at Dartmouth." It then shows the kind of sen-
sitivity to the impact of the rejection that one would expect from
a personal note, stressing that being turned down should not be
taken as evidence of inadequacy or failure.

> *The selection process does not separate qualified from unqualified
> applicants. We are convinced that most candidates for admission
> to Dartmouth would thrive academically and personally at the
> College. Of the many strong students in our applicant pool, an
> overwhelming majority is destined to perform extremely well in
> their college years. It is only the relatively small size of our first-
> year class that prevents us from selecting more of our applicants.
> This is one of the few times we wish we had a larger student
> body so we could accept more students.*

All letters that say NO would do well to say it with such sym-
pathy for the feelings of the reader.

How to collect money owed you

It's hard to write a good collection letter. You don't want to
irritate your reader. But you do want to get the money.

Watch your tone of voice. If you're reminding somebody that
a payment is a few days overdue, don't sound as though
you're about to call in the lawyers.

Bad	Better
Dear Mr. Jones:	*Dear Mr. Jones:*
It has come to our attention	*I'm writing to let you know*
that you have failed to remit	*that your June payment (due*
your June payment, which	*on June 12) hasn't reached us*
became overdue on June 12.	*yet.*

On the other hand, if you *are* going to take legal action, don't pussyfoot around. Come right out and say what you mean:

> *Dear Mr. Hinson:*
>
> *Your June payment is now three months overdue. You have not responded to three letters in which I asked if you thought there was an error in the bill. I cannot reach you by telephone.*
>
> *Therefore I'm asking our lawyers to collect the $104.56 that you owe us.*

Watch your choice of words. Never use words that suggest that your reader is a criminal. "Delinquent" is a favorite of bill collectors, as in "You have been delinquent in meeting your payments for two months in a row." Your object is to collect; irritating your readers is not likely to send them to their checkbooks.

Don't imply that your reader is a *liar*. If a woman has written you that she paid her bill promptly on the first of each of the last four months, and you have received no payments, don't write, "You claim that you paid your bill each . . ." The word "claim" reeks of disbelief. If she *is* lying, it won't help. If she *isn't*, it will infuriate her. Better to take her at her word and suggest a positive next step:

Dear Ms. Bossler:

Although you've been mailing your payments promptly, we have no record of receiving them.	**Assumes truthfulness**
Perhaps the error is in our records. Since you have been paying by check, your bank will by now have returned two and perhaps three of your canceled checks, if in fact we have deposited them.	**Admits possibility of own error**
Please look for them and if you find them, send us photocopies at our expense so we can correct our records.	**Suggests constructive action**
If you cannot find the canceled checks, we must assume the payments somehow got lost. Would you then send us a new check covering at least the first three payments, and preferably all four?	**Ask for payment courteously but firmly**
I enclose an addressed, stamped envelope.	**Reduces likelihood of yet another "lost" check**
Yours truly,	

There is nothing in such a letter to irritate an innocent customer; nor is there any loophole for further delay on the part of a guilty one. Keep in mind that your purpose is not to make your reader angry, but to get the money that's owed you.

How to complain

Never write just to let off steam. Write to get something done—your money back, or faster service, or a mistake rectified. Is the person who will read your letter at fault for what went wrong? If not, there's no point in getting sore in your letter. While anger has its place in correspondence as in life, more often than

not you'll get better results from a cool, lucid statement of what's gone wrong and what you'd like done about it.

Include *everything* your reader needs to know to take action—account number, item number, pertinent dates, form numbers, photocopies of canceled checks, photocopies of bills. If you leave anything out, you may have to wait through another round of correspondence before you make progress.

Put your complaint and what you want done about it in the first sentence.

The sweater I ordered for my son's birthday never arrived. Please send another immediately.

Ask for a reply with a specific statement of what the next step will be:

Please let me know what action you plan to take, and when.

If you are not the person who handles this, please get my letter to the right person at once. And please let me know that you've done so, and who it is. I'd appreciate that information by Friday, May 10, at the latest.

Be clear. Be complete—and you can toss in a heartrending description of what you have suffered. Be firm. Be courteous. That's the kind of letter that usually gets fast results. If it fails, raise hell. Write to the head of the organization and include all correspondence. Nine times out of ten you'll get satisfaction from the boss.

How to answer complaints

Never be defensive. If the complaint is reasonable, say so—and say what you're going to do about it. Neiman Marcus,

the Dallas-based chain of department stores, has built much
of its reputation on its responsiveness to customers. Here is
how then-Chairman Richard Marcus replied to one cus-
tomer's complaint:

Dear Ms. Klugman:

I am astonished to learn of the shoddy service you recently received from our Mail Order Department, and there is no excuse for the lack of response and discourteous conversation you had with a member of our Mail Order phone staff.	**Accepts the complaint at face value**
I'm asking Mr. Ron Foppen, senior vice-president and director of our Mail Order operation, to investigate this matter immediately, and he will personally contact you within a few days.	**Says what he's going to do about it**
I apologize for any inconvenience and embarrassment we may have caused you, and trust that we will have the opportunity of serving you better in the future.	**Apologizes** **Asks for continued business**

Yours sincerely,
Richard Marcus

Far from being defensive, Mr. Marcus comes right out and
calls the store's service "shoddy" and says that "there is no
excuse" for it. Despite the cliché apology, "for any inconve-
nience we may have caused you," the entire letter sounds
personal, sympathetic, and responsive.

What if you feel that the complaint lacks any justification?

Say so, but be courteous. Intelligent readers are good at detecting the slightest hint of irritability or impatience. You should be at least as courteous on paper as you would be in person. Forthright and direct. Never sarcastic or rude.

When to use very short letters

A short letter—sometimes no longer than a sentence or two—can be highly effective.

It can establish your interest.

Dear Mr. Woodrow:

Your proposal interests us a lot. We'll get back to you as soon as we've sorted out our budget problems for next year—no later than the end of next week.

It can let your reader know what's happening, and demonstrate your thoroughness.

Dear Ms. Pruitt:

Half your shipment went out this morning, air express. The other half follows next Monday, parcel post, as you requested.

It can say thank you.

Dear Helen:

I hope you can keep Dan Murphy on our account forever. He's the best sales representative I've ever dealt with.

Important decisions, however, are seldom made impersonally in memos or letters or e-mail. "The people who remember

that something meaningful and constructive happens when two people are in the same room having a face-to-face communication—and conversely that something destructive happens when people hide behind technology to communicate—will be happiest and most successful in the new environment," says Mark McCormack, president and CEO of International Management Group, the leading sports marketing company. Even as electronic communication continues to spread, talking to the other person is still decisive.

Churchill's memos got into the subject fast:

Prime Minister to General Ismay 8 August 1943

I have crossed out on the attached paper many unsuitable names. Operations in which large numbers of men may lose their lives ought not to be described by code-words which imply a boastful and overconfident sentiment, such as "Triumphant," or, conversely, which are calculated to invest the plan with an air of despondency, such as "Woebetide," "Massacre," "Jumble," "Trouble," "Fidget," "Flimsy," "Pathetic," and "Jaundice." They ought not to be names of a frivolous character, such as "Bunnyhug," "Billingsgate," "Aperitif," and "Ballyhoo." They should not be ordinary words often used in other connections, such as "Flood," "Smooth," "Sudden," "Supreme," "Full-force," and "Fullspeed." Names of living people—Ministers or Commanders—should be avoided; e.g., "Bracken."

1. After all, the world is wide, and intelligent thought will readily supply an unlimited number of well-sounding names which do not suggest the character of the operation or disparage it in any way and do not enable some widow or mother to say that her son was killed in an operation called "Bunnyhug" or "Ballyhoo."

2. Proper names are good in this field. The heroes of antiquity, figures from Greek and Roman mythology, the constellations and stars, famous racehorses, names of British and American war heroes, could be used, provided they fall within the rules above. There are no doubt many other themes that could be suggested.

3. Care should be taken in all this process. An efficient and a successful administration manifests itself equally in small as in great matters.

6 Writing for an Audience: Presentations and Speeches

People have come to listen. You have their attention, at least at the start. If you don't want to lose it, don't waste their time. Don't bore them. Talk *to* them, not at them.

When preparing any kind of presentation or speech, the most basic principle is to think about the *audience*. Each is different and has special interests. What are the backgrounds of the people, and why are they there? What's on their collective mind? Is the setting formal or relaxed? Are you speaking in the middle of a busy workday or after a heavy evening meal? It all makes a difference in what you say and how you say it. Writing for an audience is different from writing to be read.

The logic of business communication

In the business world, there is a logic—a discipline of thinking and communication—that pushes projects, solves problems, sets plans, and moves ideas to action. To those in government

or education and nonprofit institutions, it is identified and welcomed as "businesslike." In business, it is taken for granted.

The form of communication evolves. The internal memo is fading, replaced in many cases by e-mail. For major recommendations and proposals, formal papers have been displaced for the most part by presentations—face-to-face. Instead of writing for a reader, it is writing for an *audience*.

The principal form of presentation in most organizations has become the "deck," jargon for page after page of bulleted points serving as a framework for spoken elaboration. The name probably derives from a deck of papers (like deck of cards), but decks can be delivered on overhead slides or Power Point slides on a computer, simply a deck on a screen or monitor. There's just one constant—decks are invariably horizontal. Sometimes the presenter even disappears, as when there's a request to "Send me your slides," evidence of how pervasive this form of communication has become.

While decks lack the precision and nuances of carefully crafted memos or papers, it's not productive to mourn the loss. Decks are reality, the business tool that gets things done. And the deck has its own merits, in stimulating debate and carrying discussions through several layers of management.

One of the renowned practitioners of presentation decks, the McKinsey consulting firm, uses them effectively in client "engagements." Writing in *The New Yorker*, Nicholas Lemann describes the McKinsey approach:

> *The aim of the engagement is not to give the client reading material, it's to reduce the issue to its pulsing essence. The client team comes into the room, you distribute the deck, and crisply, calmly, rationally, brilliantly, you make your "clunk points," marching through them inexorably to the one unerring strategic conclusion.*

Reducing the issue to "its pulsing essence" is what a well-done deck does best. Only key points on each page, as few words as possible. But the points on the page must point to something—some *action*.

The format carries the audience on a flow of logic:

- *Objective*
- *Background*
- *Facts*
- *Conclusions*
- *Recommendations*
- *Next steps*

In the Memorial Sloan-Kettering exhibit that follows:

- *INTERNET STRATEGY is the Objective.*
- *INTEREST IN INTERNET FOR MEDICAL INFORMATION is Background.*
- *DRIVERS OF GROWTH are Facts to be considered.*
- *LEVERAGING THE INTERNET is the Conclusion.*
- *The Recommendation is AN AUTHORITATIVE WEB SITE.*
- *Funding and Control of Content are NEXT STEPS.*

MEMORIAL SLOAN-KETTERING CANCER CENTER

Internet Strategy

**Americans are Increasingly Looking to the
Internet for Health and Medical Information**

*[Chart showing growth of on-line health
and medical information]*

Drivers of Growth

Consumers taking more active role in
managing their health *[Survey]*

Internet enables patients to educate themselves on
health-related topics *[Research]*

Managed care reducing consumers' access
to physicians, driving them to seek
alternative sources of information

By Leveraging the Power of the Internet, MSKCC Can Deliver Its Mission to a Much Broader Audience

MSKCC Mission:

"The progressive control and cure of cancer through programs of patient care, research, and education"

Education—*[Access to knowledge, disseminating findings]*
Patient Care—*[Access to expertise, patient information]*

CancerSmart will be the Authoritative Web Site for Information and Medical Advice

Cancer prevention, detection, and treatment improvement in the quality of life for those with the disease and their familie

Although There are a Number of Medical Sites, Some with Cancer Info, None Offer the Breadth and Depth of the Proposed Site

[Examples—general health, cancer organizations, specialty sites, medical advice]

To arrive at that simple structure requires a disciplined analysis of every element—alternatives, implications, costs, or any other factor that must be weighed.

A useful model to help organize that analysis, especially for complex decisions, is the Pyramid Principle, developed for McKinsey by Barbara Minto:

THE PYRAMID PRINCIPLE

The easiest order is to receive the major, more abstract ideas before the minor, supporting ones. And since the major ideas are always derived from the minor ones, the ideal structure of the ideas will always be a pyramid of groups of ideas tied together by a single overall thought.

PURCHASE A LARGE FRANCHISE

Grow faster than industry		Positive financial impact			Easy to absorb		
Large market	Few competitors	Low cost	Growing sales	Rising profits	Separate business	Same managers	Simple controls

Within that pyramidal structure, the ideas will relate vertically— in that a point at any level will always be a summary of the ideas grouped below; and horizontally—in that the ideas will have been grouped together because they present a logical argument.

While not every presentation fits neatly into a pyramid structure—each must reflect the business issue under consideration—the principle can be helpful in organizing the logic and

thinking. Minto notes that most people only have a hazy notion of their ideas when they sit down to write, and cannot know precisely what they think until forced to work it out. "How do I know what I think," asked novelist E. M. Forster, "until I see what I write?"

How to Organize a Presentation

Organizing a presentation is a combination of clear thinking (the pyramid principle, for example) and clear communications (points that follow here).

The setting is most likely a conference room. It's a business environment. Everything you say, everything you show, every device you use, must move you toward your objectives in a businesslike fashion.

1. Keep things simple—keep them on target

Start with specific, written objectives—and a strategy. You need a theme to give your presentation unity and direction, and to fix your purpose in your audience's mind. Make it a simple theme, easy to remember, and open with it, using a headline to state it:

DOUBLE YOUR SALES

CUT YOUR COSTS

NEEDED: A NEW BALLPARK

MORE FUN FOR BOSTONIANS

Tie every element in your presentation to the theme. If

you're using charts, put your theme all by itself on one chart and place it where it will be visible throughout the presentation. This keeps the people in your audience—sometimes sleepy, often distracted, always with lots on their minds— focused on your theme (and message).

2. Tell your audience where you're going

Show an agenda that lists the points you are going to cover. Describe the structure of your presentation, and say how long it will take. Estimate time conservatively—err on the long side rather than the short side. A presentation that is promised for twenty minutes and goes twenty-five seems like an eternity. The same thing promised for thirty minutes seems short in twenty-five, crisp and businesslike.

Throughout the meeting, refer to the agenda to keep your audience on track. Prepare a presentation book the audience can keep, and tell them at the start that you'll give them copies after the meeting. This will relieve them from taking voluminous notes (instead of listening), so you'll get their full attention.

Do everything that's been asked—and a little more. Be precise and complete in covering what was requested. If you cannot cover some point or other, say so and say why.

3. Talk about *them*, not about us

While you are talking about *your* credentials and *your* achievements, the people in the audience are thinking about *their* organization, *their* business, *their* problems. The biggest single mistake in presentations is to start by cataloging your credentials, telling people how terrific you are.

*The authors learned in the advertising business that the best pre-
sentations soliciting new business started with research in the
prospect's market. Even small-scale studies riveted the audience
from the start. These insights into the prospect's problems set up
the agency's recommendations. Our credentials came at the end,
and were often not needed. By then, we had made the sale or not.*

Relate what you offer to your audience's needs. Present
everything possible in terms of benefits to the audience.

4. Think headlines, not labels

Presenters often have impressive data on their charts, but fail
to extract what the data shows, so the audience doesn't
understand what the numbers prove. What does your data
say? Headings on charts should tell the audience how to think
about the numbers:

Use	Instead of
"Low price competition is gaining"	*"Trends"*
"Our edge is service"	*"Why Acme?"*
"Insurance ratings are a problem"	*"Constraints on business"*
"We have to improve service"	*"Conclusion"*

Use headings to establish your main points. Guide the audi-
ence by numbering them on charts or slides, telling people
how many you have.

Introductory Strategy

1. *Small markets before large ones.*

2. *Three new markets every six months.*

3. *Concentrate construction in spring and summer.*

Read every word on the screen or chart to the audience. Don't paraphrase. Some presenters think it is unnecessary, even childish, to read verbatim. But no matter what you do, your audience will read what's in front of their eyes. If what they are hearing is something other than what they are seeing, they will be distracted and confused. Read everything up there, then comment or expand on it. You will no longer be competing with your slides or charts for your audience's attention.

If your style is to ad-lib, put only key words or phrases on your charts or slides.

Problems

Price	*Japan*
Quality control	*Sweden*

Face the audience when you present. Many people turn their backs and read from the screen, especially when using overhead slides. Work from the slide itself or from a script. It pays to avoid dark rooms with slides (particularly after lunch). Computer projection or charts keep the lights on and the audience alert.

5. Involve the audience

Look for interesting visual devices to present dry, routine materials. A little creativity goes a long way. New computer programs make it easy to do colorful things with pie charts and bar charts. Newsmagazines hire top artists to make their charts interesting and clear. *USA Today* is particularly adept at charts, and runs at least one every day in the lower left-hand corner of the front page. Study the techniques of these publications—and borrow from them.

Think of ways to involve your audience. Play games with them. Invite people to guess the answers to questions, or to predict the results of research—before you reveal them.

Try to add something extra, something *unexpected*. It demonstrates more than routine interest. You might play tape recordings of customers describing your audience's product, or quote a relevant passage from a speech your audience's chief executive made years ago, or show an excerpt from yesterday's TV news that illuminates or reinforces an important point.

David Ogilvy was famous for adding drama to his presentations. To make his point about the importance of hiring the best people, he presented his directors sets of Russian dolls—those nesting dolls that come apart to reveal successively smaller dolls inside. Around the smallest doll was a slip of paper with this message:

> If we hire people who are smaller than we are, we shall become a company of dwarfs. If we hire people who are bigger than we are, we shall become a company of giants.

"Hire people who are better than you are," Ogilvy commanded, "and pay them more if necessary. That's how we'll

become a great agency." Nobody forgot the Russian dolls— they dramatized the message.

Your dramatic flourishes must be relevant to your point. Almost everyone has been to big show-biz presentations where the entertainment overwhelms the message. Go easy on technology, which can take on a life of its own. Software programs create slides that "build," "dissolve," or "wipe," techniques that can add interest—or distract. Remember you're in business, not show business, and must communicate in order to persuade.

6. Finish strong

"Oh, give me something to remember you by" goes the song. As soon as you've gone, your audience is likely to turn its attention to other things—perhaps to presentations competitive to yours. Leave something to remember you by.

Don't let a meeting drift off into trivia. Close with a summary and a strong restatement of your proposition or recommendation. For major presentations, look for a memorable, dramatic close—something visual, perhaps a small gift that symbolizes your main point.

Keep your promise about how much time you'll take. Running longer than you said you would at the outset shows a lack of discipline.

Presenters often sprout wings and fly when confronted with an audience. They expand, tell anecdotes—and hate to sit down. If what you've written is exactly on time in rehearsal, you'll probably run over in performance. If you've been allotted twenty minutes, write for fifteen.

Leave time for questions—the Q and A session lets the audience get to know you better and could tip the decision your way. And prepare for questions. As you're writing, be alert to your inevitable weak spots. What are the holes in your argument? What alternatives did you consider? If you cannot build the answers into your presentation, be ready to handle them—briefly and respectfully, so the questioner will feel smart to have asked.

Edit—to shorten. Reorganize—to make sure your message is clear. Revise—to make it sound like you, speaking naturally.

Rehearse—always with props. You may think you know how you're going to handle your charts and other visual materials, but each presentation seems to present problems of its own. If you can, rehearse in the room where the presentation will take place. Go through your entire presentation at least twice. Only an amateur worries about overpreparing and losing an edge. The better you know what you're doing, the more spontaneous you'll seem.

Speeches That Make a Point

"You start with trying to figure out what you want to say," says speechwriter Peggy Noonan, who contributed to many of Ronald Reagan's most effective speeches. Her experience is that "... *it is harder to decide what you want to say than it is to figure out how to say it.*"

Most people have a terrible time knowing where to begin in writing a speech. The answer is not to hunt for a great opening. Not to ask around for the latest joke. The place to start is to think about who is in your audience and decide what you want to say to them.

Decide what *single* point you want them to take away. Then start writing. You can put down anything that gets you into what you want to talk about, no matter how clumsy it seems. There's time to polish it later. The point is to get rolling.

Immerse yourself in your subject long before you write. Read about it, make notes of lines that might be used, illustrative stories, items in the news that bear upon it. All will help you settle on a theme. The next step is a broad outline, with three or four major points and examples or subpoints under each. (One of the authors now does this on his computer.)

Now's the time to form a picture of the speaking situation. Is it an after-dinner address, a lecture, a seminar? Are you the only speaker or one of several? Whom do you follow on the program? Will the audience be sleepy? Keep the situation in mind as you write. It will make a difference in what you say as well as in how you say it.

In writing a speech, it helps to think about addressing one individual rather than a faceless audience. What you write should sound exactly like you talking to *somebody*.

Another trick that often works: Cross out the first several paragraphs. You'll often find your opening line halfway down the first page. Most of us have a tendency to warm up too long before throwing the pitch.

1. Frame the subject with a point of view

Some cynics maintain that the subliminal title of every speech is "How to Be More Like Me." While your audience might not look forward to a speech that actually had such a title, good speeches nearly always express a strongly held personal point of view.

H. L. Mencken compared two speeches by President Harding.

> *The first was on the simple ideals of the Elks: It was a topic close to his heart, and he had thought about it at length. The result was an excellent speech—clear, logical, forceful, and with a touch of wild, romantic beauty. But when, at a public meeting in Washington, he essayed to deliver an oration on the subject of Dante Alighieri, he quickly became so obscure and absurd that even the Diplomatic Corps began to snicker.*

Your title should reflect your point of view. A tip-off to the lack of a point of view in a speech is a lazy title or no title at all. "Remarks Before the Seventh Annual Conference."

Speech titles are different from movie or book titles, which are designed to sell tickets or books. You already have your audience there—to hear your speech as a professional duty. The less it feels like a duty and the more it can be anticipated with pleasure, the more likely you are to get full attention and to register what you want to say. An interesting title can create that sense of pleasurable anticipation.

Here are some good titles:

> *The Tree That Grows to the Sky (on Wall Street)*
>
> *Nonprofits: Five Additions to the Ten Commandments*
>
> *How to Keep Your Ads Out of Court*
>
> *Web Sites I Have Known*
>
> *When Will the Bubble Burst?*

Ideas that you believe in make good speeches. Tom Peters, author of *In Search of Excellence*, advises not to accept any topic that

you don't feel strongly about: "Stick to topics you care deeply about, and don't keep your passion buttoned inside your vest. An audience's biggest turn-on is the speaker's obvious enthusiasm."

2. Start fast

It may be "an honor and a privilege" to have been invited to speak, but that is not what people came to hear. Plunge into what you want to say. The occasion may require some pro forma opening courtesies, but keep them as short as possible.

Adlai Stevenson lost his presidential race against Eisenhower, but gained a reputation as one of the most graceful public speakers. His first appearance after being nominated (and endorsed by then-president Harry Truman) started on this note:

I accept your nomination—and your program.

I should have preferred to hear those words uttered by a stronger, a wiser, a better man than myself. But after listening to the President's speech, I even feel better about myself.

None of you, my friends, can wholly appreciate what is in my heart. I can only hope that you understand my words. They will be few.

You don't have to tell jokes. Are you funny? In small groups, do you make people laugh? If not, forget it. If you do tell a joke or anecdote, don't build up to it ("On the way here tonight . . . "). Tell the joke. Make sure your jokes are relevant to your point. Make sure they're funny—by trying them out ahead of time.

Start with that single point you want your audience to take away, then conclude with a memorable way for them to

do so. Don't just repeat it ("As I said at the beginning of this talk . . . ") but find a vivid image to register the point.

3. Write your speech to be spoken

Don't think of it as an oration. Think of it as a conversation with a friend. Ronald Reagan was a master at this. Here's how he handled the explosion of the space shuttle *Challenger* (with help attributed to Peggy Noonan).

He started by expressing grief:

> *Ladies and gentlemen, I had planned to speak to you tonight on the State of the Union, but the events of earlier today have led me to change those plans. Today is a day for mourning and remembering.*
>
> *Nancy and I are pained to the core by the tragedy of the shuttle* Challenger. *We know we share the pain with all the people of our country. This is truly a national loss.*

After paying simple tribute to the seven men and women who died and to their families, he spoke conversationally to children:

> *And I want to say something to the schoolchildren of America, who were watching the live coverage of the shuttle's takeoff. I know it's hard to understand, but sometimes painful things like this happen. It's all part of the process of exploration and discovery; it's all part of taking a chance and expanding man's horizons. The future doesn't belong to the fainthearted, it belongs to the brave . . .*

A moving and emotional talk—it's hard to call it a speech. Reagan *talked* to his audience.

Read aloud the draft of your speech, and edit it until it sounds like you talking naturally. Ghostwriters can help, but

your speech must ultimately reflect you. Never deliver a speech drafted by someone else before you have revised it to sound like you.

4. Leave them thinking

A great speech is one that inspires the audience to think about a subject from a fresh perspective. It helps a lot if you have the credibility, if the audience perceives that you are speaking from personal knowledge. Robert Rubin, described (in 1999) as "the most successful Treasury secretary of this century," is known for making good decisions. He was thus in a good position to focus his commencement speech at the University of Pennsylvania on decision making. His title: "A Healthy Respect for Uncertainty."

> As I think back over the years, I have been guided by four principles for decision making.
>
> First, the only certainty is that there is no certainty. Second, every decision, as a consequence, is a matter of weighing probabilities. Third, despite uncertainty we must decide and must act. And lastly, we need to judge decisions not only on results, but on how they are made.

He closes with a reminder of a world of increased interdependence and a plea to "recognize this reality and reject the voices of withdrawal . . ." Heavy stuff, even for a commencement, but important—and something that will leave at least some of the audience thinking.

5. No speech was ever too short

On your way out after a speech, do you remember ever thinking it was good—but a little too short? Most good talks take less than twenty minutes. Consider what you have so often had to sit through, and how much better it could have been said in few words.

When Theodor Geisel, who wrote as Dr. Seuss, was awarded an honorary college degree, he determined he would respond with the best speech ever—and the shortest. "Kids hate long speeches," he said. "They have other things on their minds at graduation." Here is his entire talk:

My Uncle Terwilliger on the Art of Eating Popovers

My uncle ordered popovers
from the restaurant's bill of fare—
And, when they were served,
he regarded them
with a penetrating stare . . .
Then he spoke Great Words of Wisdom
as he sat there on that chair:
"To eat these things,"
said my uncle,
"you must exercise great care.
You may swallow down what's solid . . .
BUT
you must spit out the air!"
And
as <u>you</u> partake of the world's bill of fare,
that's darned good advice to follow.
Do a lot of spitting out of hot air.
And be careful what you swallow.

Few of us—indeed only one of us—have Ted Geisel's talent. But it doesn't take talent to figure out what you want to say, to say it, and to sit down.

Making it sound easy

Consider speeches that have impressed you. The speaker seemed to be talking to you, not reading to you. You've got to establish contact with the audience. And that means looking out at the people, not down at the script.

Some speakers have a bag of tricks that make it easier for them merely to glance at the script now and then and spend most of their time looking around at the people in the room. Ultimately, however, the only way to do this is to *rehearse.* Rehearse what you have to say over and over until you know it almost by heart. The better you know your speech, the more spontaneous you will sound. And the more confident. What sets the memorable speaker apart from the ordinary one is confidence and presence. As somebody's mother-in-law says, "You get right up there and pretend you're just as good as anyone else." Great speakers communicate a sense of energy and enthusiasm.

It's difficult to be objective about your own speaking ability. But it can help to listen to yourself rehearse on a tape recorder. Better yet, take the traumatic step of seeing yourself on videotape. An illuminating teacher.

The most effective speeches and presentations sound as if they have been spoken, ad-lib, and not written down at all. Great presenters and speakers make it all sound so easy and so natural that one assumes it just pours out of them. It almost never does.

It sure is encouraging to have such a terrific turnout for E-Commerce Day. If the size of this audience is any indication, e-commerce is booming.

And some new figures we have suggest that it's going to keep on booming, as you're going to see in a little while. But first I thought I ought to tell you something about how we laid our hands on those figures, so you won't doubt their reliability as we go through them. It took us a lot of time and work. And it cost us a lot of money.

As a matter of fact, It cost my company $80,000 to send me here today—and that doesn't even include my meals. $80,000 is what we spent to find out what I should say. That's about $2,000 for every minute I'm up here, so I hope I have your attention.

We used the money to conduct some on-line research last month. We got responses from 3,250 companies—half of them over $5 million in revenue, half under—and validated the results with 350 phone calls.

We asked 25 questions as to whether e-commerce affects the way they do business—and if it does, *how* it does.

Lopping off two paragraphs improved this speech.

7 Plans and Reports That Make Things Happen

The best report ever written may have been Julius Caesar's *Veni, vidi, vici.* "I came, I saw, I conquered."

Reports, like Caesar's, describe the outcome of an operation. *What's happened so far.* A plan states *what we want to happen.* Both are essential to moving forward.

Making things happen depends on clear communication. The consequences of faulty organization and careless writing are severe. Unpersuasive plans go straight to the files, unacted on. Sloppy reports land in wastebaskets, unread. Problems go unrecognized or unsolved. Opportunities are missed. Things that should happen don't.

How to Write a Plan

Whether you are writing a battle plan or a business plan, your objective is the same: *action.*

"For Montgomery," wrote a biographer of the British World War II field marshal, "it was all a question of having a plan. Once you had decided what you wanted—what, in mil-

itary terms, was your aim—you made a plan, which you then implemented carefully by stages, maintaining the aim and concentrating all your resources to achieving it."

A plan starts with a clear statement of purpose. The capital campaign for the New York Botanical Garden started:

> *This plan lays the groundwork for the Garden's renaissance. It sets forth the Garden's future directions and identifies the resources required to achieve financial stability and move forward with vitality.*

The plan then outlined the purposes of each of five proposed programs within that plan:

- ***New vigor and focus for botanical science***—*a new plant studies center, endowing science, staffing the Institutes of Systematic and Economic Botany, strengthening the library, improving Herbarium access, expanding research in the forest, renovating laboratories, disseminating scientific information.*

- ***An American horticultural showcase***—*the great conservatory, building horticultural endowments, the propagation range, funding critical staff positions, expanding stewardship of the forest, completing the demonstration gardens complex, completing a plant inventory and computerizing horticulture, improving turfgrass, rebuilding the Montgomery Conifer Collection.*

- ***Environmental education***—*The Children's Adventure Garden, environmental education in the forest, hiring a graduate studies coordinator, strengthening continuing education.*

- ***The visitor's experience***—*providing additional parking, renovating the lecture hall, creating new public programming, creating a new visitor center, new signage program, undertaking audience research.*

- **Financial stability**—*supporting the growth of the annual fund, building endowment, developing earned income, conducting a capital campaign.*

The seven-year $165 million campaign went over its target and achieved almost all its goals.

You're writing for someone who will either approve your plan, send it back for more work, or reject it. Anything that confuses that decision or throws the reader off the track makes approval less likely. Cut out all irrelevancies. If you feel you have to touch on secondary or side issues, label them as such. Everything in your plan should pertain to your stated goal.

1. Build a foundation of facts

Your choice of facts should be rigorously selective. Stick to facts that relate to issues under consideration. Changes in the market. Competitive moves. New products, services or technologies. Financial issues—revenues, profit margins, return on investment. Economic or political conditions. Many plans will call for a combination of such data—and lots more besides.

Then draw conclusions from the facts. You can almost always infer one or more principles—lessons learned, either from the situation at hand or from others with analogous facts. Look for emerging patterns that could guide decisions. Finally, show how your facts bear on the action you're proposing.

Never present facts on their own, like unstrung gems. If your facts don't link together you leave your reader with information that, like a Mexican pyramid, doesn't come to a point.

2. State your recommendations clearly

What steps do you propose to take? What are your reasons?

The strategic plan for the Trustees of Reservations, a land conservation and historic preservation organization in Massachusetts, made four recommendations (which they termed "aspirations").

Aspiration 1: Save unprotected lands and properties of exceptional conservation interest or of strategic importance to the quality and character of the Massachusetts Landscape.

Aspiration 2: Offer visitors opportunities to enjoy and value our properties and join us in assuring the preservation of their scenic, historic and ecological features.

Aspiration 3: Engage and sustain active participation of a broad and diverse public in the enjoyment, appreciation and stewardship of the Massachusetts landscape.

Aspiration 4: Work with landowners, land trusts and government to protect, interconnect and enhance high quality open space to serve people and conserve nature throughout the Commonwealth.

A plan is a recommendation until it is approved. Then it becomes a commitment to action. So it must describe, step by step, exactly what is to be done.

In making your recommendation, it's always wise to consider alternatives and risks. Anticipate questions and answer them. Don't cover up problems—face them squarely. Make your proposal realistic. If your recommendation is controversial, consider including a candid list of pros and cons. Your cons should not be straw men (give the devil her due).

3. Make it a call to action

The first draft of a major plank in U.S. policy after World War II came through in a weakly worded, bureaucratic style.

> *It is essential to our security that we assist free peoples to work out their own destiny in their own way and our help must be primarily in the form of that economic and financial aid which is essential to economic stability and orderly political processes.*

Several drafts later, the same idea emerged as a ringing credo that became known as the Truman Doctrine.

> *I believe that it must be the policy of the United States to give support to free peoples who are attempting to resist subjugation by armed minorities and forces.*
>
> *I believe that it is essential to our security that we assist free peoples to work out their own destiny in their own way.*
>
> *I believe that our help must be in the form of economic and financial aid.*

Your goal is to leave no shred of doubt as to where you stand, and to arouse enthusiastic support for the action you seek.

How to Write a Report

Some reports aid the planning process; some come after it, reporting on progress or results. They cover events large and small—meetings, trips, competition, developments, good news, bad news. An intelligent appraisal of actual conditions is essential to progress. Report what is happening, and what you think should be done about it.

1. Make it clear why you're writing the report

Every report is written for a purpose.

A *conference report*, for example, has only one purpose: to record decisions taken at meetings. It does not restate arguments, offer opinions, or confer praise or blame. It records what was shown or discussed. What was decided (not why). What action is required and who will be responsible for it. When it is due. What money was authorized. It covers actions and decisions—nothing else.

A *competitive report* covers competitive activity, a *progress report* covers progress, and so on. What is the purpose, and why should anybody care? Try to engage the reader's interest in the first sentence.

This reports on a management meeting at which a new salary policy was decided.

The purpose of this report is to assess new competition—a product that could cut our sales in half.

2. Give your report a structure

Whether you start with your recommendation or lay out the facts before you reveal it, make clear where you are going.

Here is a structure that often works:

- Purpose—*why the reader should pay attention*
- Summary—*no surprise endings*
- Findings—*what facts can you marshal?*
- Conclusions—*what patterns do you see?*
- Recommendations—*what action do you propose?*
- Next steps—*costs, timing, issues to be resolved*

There is no need to parade *all* your information unless the reader needs every detail to understand your report. Put into the body of your report only those facts that are essential to your point. Relegate charts and supporting data to an appendix.

3. State the facts fully and accurately

Newspaper reporters are trained to do this with the famous five Ws—who, what, when, where, why (or how). Not a bad discipline for a writer of reports (who is, literally, a reporter).

> *The major findings are that Homebrand sales for the year to date are off 28 percent, distribution is down 20 percent, and Alien's crunchy new product is being purchased by half of all heavy users.*

An effective report states all the facts, unpleasant as well as pleasant. It never inflates their validity. If you only visited ten stores in two cities, don't refer to an "extensive store survey."

Firsthand observations lead to better reports. Get out of the office and see for yourself what's going on. A field trip often gives you more realistic answers than any amount of statistics. Or it can lead you to the right questions to ask. Generals go to the front to get a firsthand sense of the action, because seeing things gives them a feeling for what's going on, against which to judge the thousands of faceless facts that pour in to their headquarters behind the lines. Field trips are also a source of ideas. Just as important, they supply the details that add the breath of life to your reports.

Never trust your memory when collecting material for a report. Write down everything you want to remember.

> *"The horror of that moment," the King went on, "I shall never, never forget!"*

"You will, though," the Queen said, "if you don't make a
memorandum of it."
 —ALICE'S ADVENTURES IN WONDERLAND

4. Separate opinion from fact

Both are important; just make clear to your reader which is
which. Like the little boy in a newspaper cartoon who says to
his father, "I asked you for the facts of life, but what you're
giving me is opinions."

Facts are facts, regardless of who is reporting them: "It's
twenty-four degrees and the wind is from the northwest at fif-
teen miles an hour." Opinions vary depending on the
observer: "It's a pleasant winter day—brisk and bracing."

You should never leave your reader in doubt as to what is
opinion and what is fact.

Opinion stated as fact	*Opinion stated as opinion*
The information would be useful, but costs too much to obtain.	*We'd all like to lay our hands on that information, but none of us thinks it's worth what it would cost.*
We can't get started by May 1.	*To get started by May 1, I suspect we'll have to go heavily into overtime.*

The way you deploy your facts can give weight to your
opinion. Include the principal facts necessary to support your
views. Face up to those that weigh against you. But don't
throw in unnecessary or irrelevant details just to show you've
done your homework.

Facts are facts. Conclusions and recommendations are
always *opinion*.

How you *choose* facts, and how you marshal them, may well reflect the point of view that you're advocating. You can, and should, interpret the facts. But your report will stand up better, especially should it come under fire, if you make a conscious effort not to lump your facts and your opinions into a single undifferentiated pile.

Readable Annual Reports

Public companies of all sizes are required to publish their annual financial results and comment upon them to their owners, the shareholders. Likewise, schools and hospitals and other nonprofit institutions, which once a year make their case to their communities and supporters. While some use this opportunity well, a large number fail to think clearly about either the audience or the message and publish a report that is more design than substance. Many of them model their style on the worst habits of bad business writing.

Full advice on annual reports is beyond our scope here, but we would like to show how they *can* be down-to-earth—and readable.

The audience for the prose part of the annual report, as opposed to the financials, is seldom the sophisticated investor or the financial community. Often used as a general purpose corporate brochure ("a good merchandising tool"), the annual report is an opportunity for the chief executive to report on the organization's performance, its strategy, and its potential.

In recent years, two of the largest and best-established companies in the world, IBM and General Electric, have both used their reports to position themselves as possessing the vigor of vibrant start-up companies.

IBM is working to change its historic perception from con-

servative and stuffy ("Big Blue") to fresh and exciting ("New Blue"). The 1998 Report doesn't say "IBM" or "1998" on the cover—the only words are "Start up," followed by this from CEO Lou Gerstner.

> *What makes 1999 different . . . is that a historic shift—something IBM began talking about three years ago—is taking hold, and it's reshaping everything: how we work, how we shop, how we interact with our governments, how we learn, what we do at home. Every day it becomes more certain that the Internet will take its place alongside the other great transformational technologies that first challenged, and then fundamentally changed, the way things are done in the world.*

Jack Welch described the kind of company he wanted General Electric to become, in a GE annual report several years ago.

> *We want GE to become a company where people come to work every day in a rush to try something they woke up thinking about the night before. We want them to go home from work wanting to talk about what they did that day, rather than trying to forget about it. We want factories where the whistle blows and everyone wonders where the time went, and someone suddenly wonders aloud why we need a whistle. We want a company where people find a better way, every day, of doing things; and where by shaping their own work experience, they make their lives better and your company best.*
>
> *Far fetched? Fuzzy? Soft? Naïve? Not a bit. This is the type of liberated, involved, excited, boundary-less culture that is present in successful start-up enterprises. It is unheard of in an institution our size; but we want it, and we are determined we will have it.*

We like what Welch says, and we especially admire the plain way he says it. *The Economist* now matter-of-factly refers to General Electric as "the world's most admired company."

The founder of an Australian advertising agency, John Singleton, had this to say in an annual report commenting on the acquisition of his company by Ogilvy & Mather:

Well, I've never been so happy to admit I was wrong.

Just as I was 100% sure we needed an international partner to both grow the business and give our young staff greater opportunity I also knew it would come at a short-term cost.

I knew that a merger of this magnitude across so many communications disciplines would inevitably disrupt clients, staff and inevitably result in short-term set-backs for the greater long-term good.

I was 100% wrong on all counts . . .

Such candor is refreshing—and agreeable to read.

A major trend changing annual reports is "plain language" reporting of financial data. Much of the impetus comes from a Securities and Exchange Commission directive to mutual funds, already showing results:

Before

All of the funds offered in this Prospectus seek capital growth by investing in securities, primarily common stocks, that meet certain fundamental and technical standards of selection (relating primarily to earnings and revenue acceleration) and have, in the opinion of the fund manager, better-than-average potential for appreciation.

After

The fund managers look for stocks of companies that they believe will increase in value over time, using a growth investment strategy developed by American Century.

Warren Buffett, Chairman of Berkshire Hathaway, has long

produced reports admired for their literate insights as well as for the financial results they disclose. Buffett takes the trouble to make the numbers readable, proving in passing that there is no conflict between intelligibility and success. Here is a selection from his preface to the commission's *Plain English Handbook.*

There are several possible explanations as to why I and others sometimes stumble over an accounting note or indenture description. Maybe we simply don't have the technical knowledge to grasp what the writer wishes to convey. Perhaps the writer doesn't understand what he or she is talking about. In some cases, moreover, I suspect that a less-than-scrupulous issuer doesn't want us to understand a subject it feels legally obligated to touch upon.

Perhaps the most common problem, however, is that a well-intentioned and informed writer simply fails to get the message across to an intelligent, interested reader. In that case, stilted jargon and complex constructions are usually the villains.

Buffett concludes with this useful tip:

Write with a specific person in mind. When writing Berkshire Hathaway's annual report, I pretend that I'm talking to my sisters. I have no trouble picturing them: Though highly intelligent, they are not experts in accounting or finance. They will understand plain English but jargon may puzzle them. My goal is simply to give them the information I would wish them to supply me if our positions were reversed. To succeed, I don't need to be Shakespeare; I must, though, have a sincere desire to inform.

No siblings to write to? Borrow mine: Just begin with "Dear Doris and Bertie."

When even the numbers are easy to read and digest, we will really have made progress.

BUSINESS PLANS FOR NEW VENTURES

First comes the idea, then comes the money. Before the money, there's the business plan. For the entrepreneur, it's a one-time thing. For any potential investor, there are many ideas and opportunities—and many plans.

The profusion of possibilities is illustrated in a note by Professor Bill Sahlman for his course at the Harvard Business School. He describes his "ever growing stack of Internet based business plans, each proposing to 'revolutionize' an industry, each 'conservatively' projecting at least $50 million in revenues within five years based on a modest market share of under 10%, and each containing a projection of likely investor returns of over 100% per annum."

Every new venture has a "story," the term replacing "business plan" in some circles. Why should the investor believe your story? PricewaterhouseCoopers says the business plan "must convey to the reader that the company and product truly fill an unmet need in the marketplace," and lists the business issues to be addressed.

First, get to the point, and don't be long-winded. Start with an executive summary, to make the case quickly. Credibility is crucial—it pays to be candid; it's good to understate rather than exaggerate; it's vital to be clear.

Professor Murray Low at Columbia Business School identifies two top priorities:

- *Who are the people?* "I'd rather invest in an A team with a B idea than the other way around."

- *Is there a real customer?* "Markets are abstractions. There must be customers willing and able to pay."

He also points out two glaring weaknesses in many plans:

- *Mindless optimism*—like saying all that is needed is a small percentage of a large market. "That's just hoping. How will the business be built?"

- *Sloppy presentation*—like typos, spelling mistakes, careless grammar. "They haven't put the time in to make it right, so the plan will not be read. The people may be OK on vision and the big picture, but you have to question their execution."

Investors seek confidence in a good business (and a well-written plan).

8 Recommendations and Proposals That Sell Ideas

Whether you are in business, government, or the not-for-profit world, you will have to sell your ideas in writing. In written recommendations to committees or boards to take some action. In written proposals for the funding of grants. However persuasive you are in person, you will be asked to put it in writing.

The purpose is to persuade somebody—or, more often, a number of people—to approve a recommendation or proposal, and agree to put it into action. But many such documents leave their audience confused about what is being proposed. Others are clear enough, but unpersuasive. Some are so poorly put together that they cast doubt on the value of the project or the competence of the proposer, and can even unsell a favorably disposed audience.

Unless you are able to sell your ideas, you might as well not have had them.

Recommendations That Persuade

All organizations spend lots of time preparing recommendations, often with several options. Henry Kissinger used to say that State Department memos commonly offer three options: the first leads to nuclear war, the second to unconditional surrender, and the third is what they want you to choose.

To get the decision you seek, keep in mind that you have been living with the subject and your audience has not, or at least not with the same intensity. You have to bring people into your subject before you can persuade them. Remember too that you are usually in competition with other recommendations for finite resources. You must be more convincing and make a persuasive case.

Here are some principles for making a persuasive case:

1. Think of it as selling—not as presenting

Just laying out your views is not enough. You must marshal both logic and passion behind your facts. Anticipate your audience's reservations and face them squarely. Instill confidence that you have thought hard about potential pitfalls, and are fully prepared to guide the venture around them safely and successfully.

That starts with the title—which should promise a benefit. Why is this worth the reader's time and attention?

2. Tell people where you are going

Your first paragraph should establish both your subject *and* its scope. The strategy for Harry Truman's successful campaign

for the presidency in 1948, spelled out in a forty-three-page memo, started with this paragraph:

> *The aim of this memorandum is to outline a course of political conduct for the Administration extending from November, 1947, to November, 1948. The basic premise of this memorandum—that the Democratic Party is an unhappy alliance of Southern conservatives, Western progressives and Big City labor—is very trite, but it is also very true. And it is equally true that the success or failure of the Democratic leadership can be precisely measured by its ability to lead enough members of these three misfit groups to the polls on the first Tuesday after the first Monday of November, 1948.*

In pointing out where you're going, it often helps to remind people where you're coming from. Persuasive recommendations usually include a section on background—earlier decisions or familiar information into which this recommendation fits.

If you have done an impressively thorough job in arriving at your recommendation, it pays to spell that out in the background. To persuade the board of managers of the New York Botanical Garden that its recommendations were soundly based, a management consulting firm summarized its wide-ranging activities:

> *Reviews with the staff of major programs and functions; analysis of financial records, interviews with Board members; visits to three other botanical gardens; comparison of the Board structure and fund-raising activities with those of other comparable New York institutions; preliminary interviews with foundations, corporations and government officials to gauge the outlook for future funding.*

This background, demonstrating that no stone had been left unturned, prepared the audience to respond favorably to the report's findings, conclusions, and far-reaching recommendations.

For long recommendations, it's helpful to start with an executive summary. Include all main points, a sentence or two for each. Let the full document fill in the details.

3. Lead people through with headings

It helps your audience to follow your train of thought if you keep it on track with bulleted or numbered headings.

A recommendation to advertise on television headed each section clearly:

WHY TELEVISION?—It's Media Smart

- *It Provides the Needed Extra Impact*
- *It Extends the Person-to-Person Print Campaign*

WHAT DID OUR RESEARCH SHOW?—Review of Objectives and Methodology

- *Television Findings—Breakthrough Quality was Key*
- *Television Shifted Respondents' Perceptions*
- *Television Proved Unique Advantages over Print*

WHAT IS OUR CREATIVE RECOMMENDATION?

- *TV Goals*

Headings help put your points in the context of your total recommendation.

4. Recommend—and do it early

This is a recommendation, not a story with a surprise ending. Busy people don't want to guess what you're leading up to, so get to the point quickly and clearly.

> *We propose that a new environmental program be launched within six months.*

> *The committee recommends a new organizational structure to focus more on clients and markets.*

Most recommendations involve a degree of pain—a new and expensive investment, or a difficult trade-off. Delaying the bad news is not going to help. Get it up front. Then lay out specific reasons in support. The rationale for your recommendation is the heart of your argument. What is the evidence?

Ogilvy & Mather recommended an expensive campaign of large newspaper ads consisting mostly of text. To forestall a likely client objection that "nobody reads long copy in advertisements," the recommendation cited numerous cases of ads with hundreds, even thousands, of words that had produced terrific results:

- *A single British Travel Authority advertisement with over a thousand words attracted 25,000 responses. BritRail, a primary cooperator, reported "its best sales year ever in the U.S."*

- *An all-type campaign for International Paper drew a thousand letters a day commenting on the advertising or requesting reprints.*

- *For Cunard, an advertisement with 26 separate paragraphs of information paid for itself four times over in direct sales.*

Specifics persuade. But they must be relevant and impressive—every one of them. A chain of specifics is no stronger than its weakest link; the weak one will attract the attention of your critics in the audience (and distract your friends).

It's wise to anticipate questions that are likely to be asked. But sometimes a question that may seem devastating doesn't really strike at the heart of the matter. In such cases, reframe the question. The question Ogilvy & Mather anticipated was "Does anybody read long copy?" The recommendation reframed it so that the reply would reveal what the questioner actually needed to know: "Does long copy *sell?*"

5. Emphasize the benefits of your recommendation

There must be a payoff in a reasonable time if your recommendation is to be accepted and acted on. A recommendation by a management consultant emphasized these goals:

> *To achieve sustainable competitive advantage in cost, technology, and systems quality.*

> *To reach an appropriate return on investment.*

> *To maintain the highest levels of customer satisfaction.*

> *To improve the use of key people.*

The recommendation went on to show how those objectives would be met. Never fail to answer the main question your audience is asking, however silently: *"What's in it for me?"*

Proposals That Win Grants

Foundations and government agencies that grant money have an unhappy dilemma: having to say "no" far more often than they say "yes." Much more money is asked for, and for deserving causes, than there is money to give. Whether you're applying to a federal agency or making your case to a foundation, it is possible to stand out from the crowd. And there will be a crowd.

Talking about measurable program results ("outcomes," as they're termed), shows professional expertise—and makes your proposal stand out. Here are some other principles:

1. Get to the point—fast

"I know the head of a major foundation who says he's tempted to toss out any proposal that doesn't tell him *quickly*—in the first paragraph or second—how much money is requested, and what it's for," says one professional fund-raiser.

Not every foundation head is as tough as that one, nor should the direction to tell it all in the first paragraph or two be taken literally. But the nearer the beginning the better.

2. Show how your project meets their needs

Most funding sources have published the goals and criteria against which they make their decisions. Your opening paragraph should show that you understand this—and how your project fits. Here is the first paragraph of a proposal from the National Organization on Disability to a foundation that focuses its funds on supporting community programs:

> *The Community Partnership Program is N.O.D.'s flagship program, supporting a network of 4,500 communities around the United States. This voluntary network brings together citizens with and without disabilities in many significant community-building activities. It is our belief that American communities have the ingenuity and initiative to address disability issues directly at the grassroots level.*

Be realistic in what you hope to accomplish. Better to identify a single specific problem that you might actually solve than to appear to be trying to cure all the ills of society.

Regardless of the outcome you promise, your own credibility is important. How long have you been around? What is your track record? It's not enough just to establish the importance of your project. You must persuade your reader that you can make it happen.

3. Organize to persuade

Many proposals make life easier for the decision maker—they are easy to turn down because their authors don't organize their material persuasively. Typically there are a series of points, often numbered to give the appearance of structure. But the proposal doesn't relate the points to one another or fit them together to make a case. Claims are not supported by evidence. Facts, while impressive in themselves, don't bear on the argument.

Organizing material to make a persuasive case calls for logic, rigor, and discipline. It is often the hardest part of writing, and bedevils every writer engaged in advocacy of any kind. Many of the changes from draft to draft of this book resulted from a struggle to connect examples precisely to the points they illustrate. We had to force ourselves to throw out a lot of good writing that was not quite relevant.

Everything relevant, nothing extraneous—that should be your goal in writing your proposal. To the extent you succeed, your proposal will rise above your competitors' for that all too limited pot of money.

4. Make it urgent

The thought that must be communicated is that the project might not happen if there is no funding. "You can make the difference," is one way to get a "yes."

The introduction of a proposal by the National Academy Foundation identified the urgent need for an educated workforce to participate in the advancement of the U.S. economy in an increasingly global marketplace.

> *A review of recent educational findings reveals that we are far from developing such a workforce or even one on parity with that of other industrialized nations. For example, we find that American schoolchildren are typically found at the bottom of international comparisons of mathematics and science, and the majority of students seeking Ph.D. degrees in mathematics and engineering from American universities are from foreign countries.*

For continuing programs, it is important to present a plan that will assure some kind of continuing support after the grant runs out—so the program doesn't die.

5. Improve your product

While a well-written proposal is important, what really counts is a strong, viable program. Applicants for grants are offering us an *opportunity*, says Karen Rosa of the Altman Foundation. "We want to know who they are, what they do, and for

renewal requests, did they do what they said they would do."

A proposal from the Brooklyn Youth Chorus gets high marks because it describes a carefully constructed program and captures the essence of the chorus through impressive statistics and heartwarming photos of the kids. The covering letter radiates accomplishment, then quickly moves on to spell out how this successful group is working hard at getting better and better.

> *The Russian tour was an absolutely great experience for the Choristers and we are now starting our season with a wealth of scheduled appearances. I am particularly excited about our October 17th Carnegie Hall collaboration with the Montreal Symphony, conducted by Charles Dutoit. The Brooklyn Youth Chorus Festival 2000 is shaping up to be a great event as well.*
>
> *The Chorus continued to grow in many ways during FY 1999. We completed our strategic plan, increased enrollment, hired a Children's Voice Specialist and an Associate Conductor, started individualized vocal and instrumental instruction, and opened a new Saturday chorus division.*
>
> *During the coming year we will continue to expand enrollment, initiate the new Intermediate Chorus, present our Festival, support other choruses through our new Partnership program, and conduct a new series of teacher-training workshops.*

How important is the quality of the writing? Very important, says Rosa, particularly in applications from educational programs. "Proposals filled with spelling and grammatical mistakes drive me crazy. How secure can we feel about your ability to teach kids if you can't spell?" But, she concludes, more time should be spent improving the product than improving the proposal.

6. It need not be dull

A successful proposal, by the South-North News Service, to fund a world affairs newspaper and teachers' guide for U.S. secondary schools, opened with an arresting image.

> *Oh, to be 14 years old.*
>
> *The rigid antagonisms of the Cold War are crumbling. The white power structure of southern Africa is coming face to face with reality.*
>
> *But survey after survey shows us that neither the 14-year-olds nor their teachers can find Vietnam or Brazil on a map, or tell the difference between Tel Aviv and Cairo, or label the Indian Ocean or Antarctica.*

Put colorful detail in your proposal, like this successful one by the Hood Museum at Dartmouth College for a major exhibition, "The Age of the Marvelous."

> *During the 16th and 17th centuries, European culture was marked by an intense fascination with the Marvelous, and those things or events that were unusual, unexpected, exotic, extraordinary or rare.*

The first requirement is to get read.

9 Asking for Money: Sales and Fund-Raising Letters

Grumble all you want at the volume of your mail at home, made up of catalogs, brochures, or letters asking for money for some product or service or charity. It's unlikely to abate, as long as there's evidence that direct marketing works. People do respond—to the right appeal.

The remarkable growth of direct mail was triggered by sophisticated computer models, improved targeting of mailing lists, credit cards, 800 numbers, plus changes in lifestyles and shopping habits. Now the Internet is spawning e-mail pitches (some unsolicited, some requested by customers) which are faster, cheaper, and often get better response than postal mail. Direct mail on steroids, as some describe it.

While changes in technology have been a large part of this revolution, what hasn't changed is what to say to people (or how to say it) to get them to respond and send money. Studies show that many successful mailings use techniques that have been around since the 1930s—the same basic elements

(letter, brochure, reply card), the same kind of offer (something for nothing, or a discount), a bill-me option, long letters even to busy people who supposedly have no time to read.

The principles go back even further—to the Grand Bazaar in ancient Turkey, suggests British direct marketing guru Drayton Bird. He draws an analogy to contemporary media:

> *Why are so many big advertisers firing blanks on the Internet? Because they think it's an advertising medium. It isn't. It's a marketing channel; a **direct** marketing medium. All Internet transactions are direct.*

Like the Turkish Bazaar ("they don't just show, they *sell*"), direct marketing is a retail medium. And nearly every technique direct marketers use, says Bird, works as well or better on the Internet.

It pays to test

Whole books have been written about sales letters and fund-raising letters, identifying dozens of principles employed by the pros. There is only one that you can never ignore: *test*.

Many of the things you think you know, like "Nobody will read anything that long," often go out the window when you test. Emotional appeals that you're sure will pull responses, often don't. If you have something that's working, be careful about changing any element without testing. What turns out to be the crucial element sometimes surprises even experienced pros.

Some organizations fly by the seat of their pants and don't know what is working and what isn't. They seldom get full value from their efforts. They don't take advantage of the *accountability* of direct marketing.

The reader responds directly to the writer or organization; you count the money that comes in and you know how

you've done. It is common to find that one mailing will produce many times the response of another for the same product. It pays to test if you plan to mail to a substantial number of people, or if you plan to mail more than once.

Testing is not just for large organizations. You will find techniques for simple low-cost tests in many books on direct marketing (we suggest one in the final chapter). If you cannot test, take advantage of the testing of others. When you receive the same mailing over and over, year after year, you can be reasonably sure it has been proven in testing. Study it.

Don't assume anything. And prepare to be surprised. Certain months (or even certain weeks or days) are more productive than others. Sometimes a higher price will produce more response than a lower one. People will respond again and again to the same mailing—don't change for the sake of change. Long letters often pull better than short ones.

Important—test only one change at a time. If you test several, you won't know which helped (or how much).

The "true value" concept

The results you get from testing lead to another principle: *Estimate how much a customer is worth.*

If you expect people to send money just once, the calculation is easy. Will you get back enough money to cover the cost of the mailing plus the cost of the merchandise—and leave you with a profit? If yes, go ahead. If no, start over.

Most direct mail is in a different category—it goes to people who may buy more than once:

- *Customers whose repeat orders you can reasonably expect—or whose satisfaction with one of your products might prompt them to buy another.*

- *Subscribers—to magazines, book clubs, record clubs, art clubs— who well might renew their subscriptions or send in new orders.*

- *Contributors to schools or hospitals or any local charity or cause, who might well give again in future years.*

For this kind of respondent, you can invest heavily in your initial mailing—even if it loses money the first time around, as it often does. This is the "true value" concept—what a customer is worth over time.

The New York Red Cross found that it paid to send first-time givers a free first-aid manual to convert them to donors—who were found to give in four of the following seven years, and increased their donations 20 percent.

To decide how much to invest in each potential customer, you must know how much each customer is ultimately worth. Often you'll have to estimate and make some assumptions. While not an exact science, it is simple arithmetic.

What Works Best in Sales Letters

Direct mail specialists can cite many principles as to what works best in sales letters. Two of those principles invariably come first.

Make sure the offer is right

The professional direct mail writer works first on the coupon, not the letter. What is the offer? How should it be stated? What are the terms?

The offer is what gets the action—especially when product differences are small or short-lived. Over the years, mailers

have offered reduced prices, premiums, charter subscriptions, free-trial offers, or a combination of these.

> *Airline mileage is the currency of many current offers. It is accumulated by millions of travelers, who see it as having high value. Discount brokers used to compete on price, but price wars in the category have ended. "Open an E*TRADE account," says a mailing from the on-line broker, "and earn a sign-up bonus of up to 10,000 Mileage Plus miles."*

You may well be amazed how something *free*, however small, can add to the power of a sales letter. A free first copy, a free membership certificate, a free pin, free trials. Even a simple pamphlet, perhaps one you've already printed for another purpose, can be an effective free offer—and a cheap one.

Small changes in an offer, or even in the way the offer is presented, can make an immense difference in response. If you test nothing else, test your offer.

"Star bursts, underlining, the 'P.S.'—those don't affect the results that much," says Howard Draft, chairman of Draft Worldwide. "If you come up with the big idea, the big offer, that's what drives business."

Start fast—in the first sentence

Even the most accomplished writers struggle to get their first sentences right. E. B. White wasn't satisfied with his first draft of *Charlotte's Web*, especially the opening, and worked on it for more than a year. He tried leading off with Wilbur the pig, Charlotte the spider, and Zuckerman's barn before deciding on this riveting first sentence:

> *"Where's Papa going with that ax?" said Fern to her mother as they were setting the table for breakfast.*

Writers of direct mail don't have a year to ponder and revise, but they do take pains over their openings. Much direct mail is read over a wastebasket—you have to get to the point quickly. Here's how one letter actually started. Guess what this letter is selling (hard if not impossible) and what's likely to happen to it (easy).

Dear Friend:

I receive, as no doubt do you, a fair number of letters asking for attention and not least for money. All, as I've often said, tell me at undue length what I already know or do not need to know. The wonderful computer errors of the Republican National Committee apart, I try to read and respond as appropriate. Nonetheless, I yearn for brevity. Not doubting that you share this yearning, I will be brief.

Compare that to the opening of this letter, which ran for years and in test after test beat all alternatives:

Quite frankly, the American Express Card is not for everyone. And not everyone who applies for Cardmembership is approved.

What the pros do

Here are some other practices followed by direct mail professionals:

1. Get people to open the envelope

Always say something on your envelope; it is what your prospects see first. Tease them. Hint at your offer. Tell them

about a gift inside—or promise valuable information.

ADVANCE NOTICE

PLEASE OPEN AT ONCE:
DATED MATERIALS INSIDE

WE HAVE A FREE GIFT FOR YOU

RECEIVE FOUR ISSUES FREE

7.8% INTEREST ON AND ON (Not an introductory offer)

2. Find the audience, then the message

A sales letter is an advertisement delivered in the mail. Successful advertising starts with a persuasive strategy; strategies start not with what to say, but to whom—*the target*. It's only human to try to appeal to everybody. A radio commercial began, "Hey there, men! And that includes you girls." Resist that temptation.

Try to form a realistic picture of your prospects—age and income, lifestyle and attitudes, the products they use. Then determine the single most important benefit your product or service offers. Most have several benefits, but one must be more important to your prospects than the others. The essence of a successful strategy is sacrifice; play down lesser benefits to concentrate on the one with the most sales power.

3. Favor long letters over short ones

Most amateurs assume people won't read more than a page or two at most. The fact is that long letters generally pull better than short ones—if you:

- *Grab the reader's attention at the beginning*

- *Load the letter with relevant facts*

- *Have an attractive offer*

Look at the mailings you receive. How many are just one page, and how many are several pages long—and include several pieces of literature?

One of the largest and most successful direct marketing companies, Publishers Clearing House, sends a package that includes six enclosures plus a letter almost a thousand words long. You are asking your readers to make an investment—in time, money, or both—and must convince them that what you're selling is worth it.

4. Make it inviting to read

People won't read letters that look formidable, with long blocks of text.

Use visual devices—like this inset paragraph—to make your letter look inviting and interesting, and easy to get through. Headings (like "Make it inviting to read" above) and handwritten notes also work.

Think beyond standard envelopes and standard sizes of paper. The most effective mail is often an unusual size, shape, or color. But keep in mind that letters should look like letters, not like advertisements. Coupons should look like coupons (or money), certificates like college diplomas or high-grade bonds.

Coupons and certificates are conventions that readers understand at a glance. Making them look like something else, to be different, defeats their purpose.

5. Don't let the reader off the hook

People procrastinate. You must create a reason for your prospect to act now.

Danny Newman, America's most successful seller of subscriptions to concert and theatrical seasons, builds all his mailings from a single injunction: SUBSCRIBE NOW.

The P.S. is one of the best-read parts of any letter. Use it to remind the reader of some important detail, to restate your offer, to create a sense of urgency with a deadline or a special premium. *Amazon.com* introduced its new on-line auction service in a letter with this closing note:

> *P.S. We've worked hard for many months to bring you Amazon.com Auctions and we're super-proud of it. As an Amazon.com customer, you're pre-registered for both buying and selling. I think you'll be surprised how easy it is to use. For a short time, we're also doing a promotion where first-time buyers receive a $10 Amazon.com gift certificate. Please come and give it a look at www.amazon.com—just click the Auctions tab.*

P.S. Even if the P.S. doesn't affect results "that much," a small effect can be worthwhile. And the P.S. doesn't add a penny to the cost of your mailing.

What Works Best in Fund-Raising Letters

In the world of political fund-raising by mail, two acknowledged masters are Richard Viguerie and Roger Craver, a conservative and a liberal. Craver disagrees with Viguerie on every issue, observes the *New York Times*, "except on how to write a letter."

"You need a letter filled with ideas and passion," says Craver. "It does not beat around the bush, it is not academic, it

is not objective. The toughest thing is to get the envelope open. The next toughest thing is to get the person to read the letter."

A Craver letter for handgun control carried this message on the envelope:

ENCLOSED: Your first chance to tell the National Rifle Association to go to hell!

The letter starts:

Dear Potential Handgun Victim

To raise money for charitable, educational, or political causes, you must appeal to the emotions. People can have strong feelings about the causes represented by a community fund, about a political candidate, about a religious institution. They want to give. Yet those new to fund-raising are often hesitant about asking for money.

People who have given previously are the best source of funds. Many studies have shown that most first-year donors will renew in year two, and an even larger percent of retained donors from year two will renew each subsequent year. Often those donors will increase their gifts. They may participate in deferred giving programs. They will even help acquire new donors by working as volunteers.

These facts are at the heart of direct mail fund-raising. They lead to two central conclusions:

It pays to invest to get new donors.
It pays to invest in building a relationship.

The stakes are clear. Nonprofit organizations depend increasingly on private support for their survival, and direct mail is a crucial source of funds for charitable institutions.

1. Say thanks, then please

Donors are believers, and believers give. You can go to them on a regular schedule or in emergencies. Write to them regularly, and keep them informed about the organization and its activities. Make them members, not just givers. Send membership certificates and pins. Then, when it comes time to renew their support, they need only an inexpensive reminder to prompt their generosity and loyalty.

Here too, free gifts, even token ones, add to the effectiveness of your mailing.

Write to say thanks. Thanks, *and won't you give again?*

A successful fund-raising letter from the general director of the Lyric Opera of Chicago began by thanking donors for all they had done for the company the previous year. The first paragraph ended, "I just wanted to be sure to say 'Thanks' before I say 'Please.'"

2. Tell the prospect how much money you want

The reader does not know how much money you expect. Suggesting the size of the contribution is up to you.

Upward Inc., an after-school program in New York, made this successful appeal:

> *Here's a holiday gift idea—how about giving a computer to a kid in Harlem (for about $800)? Upward Inc. needs a few people like you to rebuild its computer center in order to put inner city children on their life path "upward."*

At the same time, you don't want to discourage smaller gifts. The Upward Inc. letter went on to suggest at least contributing something toward the price of a computer monitor at $300.

It can be effective to tell readers what different services cost, so they can select a giving level. Another letter from Lyric Opera gives this approach a stylish twist in a note to Santa Claus:

Dear Santa:

It would be lovely if you could leave an $8 million check in my stocking this year—but I know that's a bit much to ask. So let me list some of the things we really do need, that maybe you can help us with.

> *Children's Backstage Tour ($7,500)*
> *Senior Citizens' Matinee ($15,000)*
> *Airfare to bring artists from New York ($325 each)*
> *Ballet shoes ($75 each)*
> *Wigs and make-up for the chorus of* Mefistofele *($5,500)*
> *Leaves to redecorate the tree in* Elixir of Love *($550)*
> *Rental of keyboard for sound effects ($3,607)*
> *Youth Education programs ($15,000)*

If I listed everything Lyric needs, or needs money to fund, this letter would go on for pages—so I've selected only a few items that are especially on my mind as the holidays approach.

3. Put your appeal in personal terms

People would rather give to other people than to faceless institutions. Alan Reich founded and runs the National Organization on Disability from his wheelchair. He writes to a friend:

The last time we were together, we spoke about a project of great importance to people with disabilities. It is the addition of a statue

of President Roosevelt in his wheelchair at the FDR Memorial.
Congress passed legislation mandating that the statue be added. It
also requires that the $1.65 million be raised in the private sector,
and N.O.D. has taken on this challenge.

I am writing to request your help, because I regard you and
FDR as kindred spirits, at least in triumphing over disability.

Your letter should tell readers what's going on, the work
your institution is doing, and why it is important. Tell them
about the things you can't do—unless they give. Don't let
them assume the drive will be successful whether or not they
give. This adds urgency to your appeal.

Unless we hear from you right away, we may be forced to close
down two Morgan Memorial buildings.

Westminster Abbey is falling down. If this doesn't move you,
read no further.

Don't forget to tell people how little you spend on adminis-
tration. Assure them that you mean it when you say no con-
tribution is too small, even a dollar.

––––––––––

Nobody likes a mailbox full of junk mail. However, one per-
son's junk is another's passion. Susan cannot get enough gar-
den catalogs, George enough cookbooks. Junk mail is mail
that is inappropriate—because it is talking to the wrong per-
son, talking at the wrong time, or talking in the wrong tone.

Direct mail was once "pretty intrusive," acknowledges
Howard Draft. "But now we're trying to understand what a
customer's needs are and how to create an invitational
approach."

People read direct mail and they act on it—if the product or service or cause is something they want or believe in, and if they trust the mailer. The single most important thing you can do to send money through the mail is to convince people that they can trust you.

Never exaggerate, either in word or picture, what you are offering, or when you will deliver, or any other detail. If, for some unforeseen reason, you can't live up to a promise, send a postcard saying so; apologize; and say what you're going to do about it. The trust you build will be well worth the extra cost.

10 Coping with Political Correctness

". . . I believe in courtesy, the ritual by which we avoid hurting other people's feelings by satisfying our egos." So says Kenneth Clark in the conclusion of his classic book *Civilization,* revealing himself "in my true colors, as a stick-in-the-mud."

A similar old-fashioned respect for the feelings of others has ballooned into what is called, often scornfully, "political correctness" in speech and writing. It is all too easy, however, to ridicule the politically correct language police, ever on guard against any word or expression that might possibly offend anybody anywhere. The suggestion, for example, that *All The King's Men,* deemed doubly sexist with "king" and "men," should be retroactively retitled *All the Monarch's People,* deserves the hoots and hollers it arouses. And a bit later we will unload a few hoots and hollers ourselves.

Nonetheless we respect the underlying impulse of politically correct writing and commend it to you. It arises from sensitivity to the feelings of readers. You would be wise to be

alert to the power of words to distress and infuriate people, and to do your best not to wield that power recklessly. As a country song puts it, "sticks and stones can break my bones, but words can break my heart."

Bernard Shaw defined a gentleman as somebody who "never insults a person unintentionally." In business writing we try to be gentlemen in just that sense. We make a conscious effort not to insult people—nor offend, nor upset them—unwittingly and by accident. It is good business as well as good manners. Why rile up your customer or your client or your prospect?

From time to time, for one reason or another, you may have reason to use a word or an expression which you know will rub somebody wrong. When you do so, you should be prepared to face the consequences with your eyes wide open.

Sensitive—but not hypersensitive

Gender, race, ethnic origin, age, and sexual preference are where most of the sensitivities reside. Our policy is to be sensitive but not hypersensitive.

Minority groups often have strong feelings about the terms used to refer to them, and their preferences can change over the years. "Negro" was the polite term for decades. After it was replaced by "black" and "African American," Negro became a target of derision among black comedians. If preferences should change again, so what? Use whatever happens to be the current preference of the group in question—and take the trouble to find out what that is. Minorities suffer enough without being labeled with terms they regard as offensive, regardless of what the writer may think of their preferences or their reasons.

You should not, however, feel obliged to scrutinize in depth every word in your vocabulary for possible derogatory connotations. Some years ago the Multicultural Management Program at the University of Missouri School of Journalism published a checklist of words that journalists should be wary of. The fifteen-page list contained over two hundred entries, including:

Fried chicken	*Matronly*	*Crippled*
Burly	*Dutch treat*	*Feminine*
Buxom	*Illegal alien*	*Ghetto*
Warpath	*Shiftless*	*Jocks*
Gyp	*Elderly*	

Commenting on this "bad word dictionary," the late columnist Mike Royko wrote that "the age of super-sensitivity is crushing me." By the end of his column, though, Royko had become uncrushed enough to assert that "when I put together a softball team, I'll recruit real jocks, not a bunch of wimps, nerds, dweebs or weenies" and "I'll continue to go have Dutch-treat lunches with my friends and check the bill to make sure the waiter didn't gyp me."

Perhaps the most remarkable entry on the list is "without rhythm," objectionable, the journalism school's compilers explain, as "a stereotype about whites. Implies that others have rhythm, also a stereotype."

In an editorial bemoaning the proliferation of offended groups, the *Wall Street Journal* said: "Today, alas, we have created whole classes of the perpetually aggrieved, built on the notion that if someone takes offense, then an image or name is ipso facto offensive."

What is one to make of the sad case of the aide to the mayor

of Washington, D.C., who lost his job because, discussing budget matters, he used the word "niggardly"? He used it in its correct meaning—miserly, stingy—which bears no connection, either in common usage or lexicography, to the offensive term for African Americans that it resembles. Nonetheless he was misunderstood. He regarded his own failure to anticipate the misunderstanding, and the distress it caused, as awful enough to require him to resign. The mayor agreed, and accepted his resignation. Such an event brings into pointed opposition the standards of political correctness and those of freedom of speech.

"Can speech ever be both correct and free?" asks the headline of a recent article in the "Ethics Today" column of the *Financial Times*. "The line we seek to draw is elusive," writes the columnist, Joe Rogaly. We should "debar public use of language that foments antipathy towards others, but . . . should also allow everyone to speak his or her mind. It is one of those things none of us will ever get quite right. When in doubt, I say favour free speech."

In principle we agree with Rogaly and come down on the side of free speech. We admire writers, editors, and public figures who keep their eye on the first amendment to the U.S. Constitution, and we deplore the preposterous fate of the literate bureaucrat who spoke rightly but not freely with "niggardly." In business writing, however, we would move Rogaly's "elusive line" a few inches in the direction of what's purely practical, encouraging you to place a lot of emphasis on the probable consequences of your choice of words. If you know that writing "niggardly" is likely to be misunderstood and to cause anger or pain, what's wrong with writing "stingy" instead?

In other chapters you will find lists of do's and don'ts, firm opinions on what's good and what's bad. In the matters

under consideration here no such specific guidance is desirable. Sensitivities vary from audience to audience. An expression that ruffles feathers in one context will breeze by uneventfully in another. Words that one person can safely write may be anathema coming from somebody else. Just do your best to be as considerate of the feelings of others in writing as you would be in person. That will take you a long way toward achieving the underlying purposes of political correctness while avoiding its excesses.

He, she, and everybody

We do, however, have specific suggestions on how to handle one common writing problem. That is the convention of male-oriented language used in reference to all people—for example, "he" as a collective pronoun referring to women as well as men. This convention is pretty much obsolete, but what replaces it can be awkward or grating.

"He or she," for example, as in "Every novelist hopes that he or she will win the Pulitzer Prize," is okay once in a while but becomes tedious and self-conscious with repetition, and in some cases ludicrous—e.g., give the devil his or her due. This problem is often poorly solved by a reckless disregard for grammar: "Every novelist hopes that they will win the Pulitzer Prize." Some people, otherwise sticklers for proper English, make an exception for this construction, arguing that everybody has a right to their own priorities in solving problems of political correctness. We say that everybody (always singular) has a right to *his* priorities, or to *her* priorities, or to *his or hers*, but no individual of either sex has a right to *their*

priorities.‛ "Every novelist hopes they'll win" grates on many ears as badly as would "Every novelist hope he'll win."

Fortunately there is a simple way to be correct both grammatically and politically. Just put the point into the plural: "All novelists hope they will win the Pulitzer Prize." Converting a subject from singular to plural works nicely in most instances. Another trick of the trade is to switch from the third person to the second person: instead of "when an employee receives a message addressed to him or her," write "when you receive a message addressed to you."

In this book we occasionally use "she" or "her" when we want the reader to understand that we are referring to either a man or a woman, and in other cases in similar constructions with a similar meaning we use the conventional "he" or "him." We believe that this scattershot method of giving equal representation to women and men is clear to both and offensive to neither.

An assumption, touched on earlier, lies under everything in this chapter. We assume that readers whom you've angered or offended are unlikely to respond favorably to your message. Since much business writing, and nearly all *important* business writing, seeks a favorable response, it follows that you should try not to anger or offend your readers.

Self-interest aside, we return to Kenneth Clark and his belief in courtesy as a mark of civilized behavior. We, too, believe in courtesy, in writing as in life.

11 Writing a Resume— and Getting an Interview

Nothing else you write can make so big a difference in your life as your application for a job.

You should apply in *writing*. When you telephone for a job, you do it at *your* convenience. *You* choose the moment to call, and the chances of your potential employer being free to talk with you—or even interested in doing so—are remote. If you want to be taken seriously, communicate in writing.

What you write is a resume* and an accompanying letter. Some of these will end up in a wastebasket, unread, but a well-written approach usually earns a response. The point is to secure an interview, and that objective should guide your thinking.

**Resume* can also be *résume* (one accent) or *résumé* (two accents), depending on which dictionary you consult. Since the accent keys in word processing programs can be a nuisance to activate (and few typewriters have such keys), resume is common usage in business correspondence.

The resume is a crucial part of the process. *But it won't get you a job.* Companies don't hire resumes, they hire people— and they make those decisions in an interview. So why is your resume so important? A good resume—one that's relevant, clear, and concise—is a lot more likely to lead to an interview than a poor one. This is true whether your resume arrives in the mail or over the Internet.

A good resume also helps you prepare for a better interview. Many job applicants walk into an interview without having organized their thoughts about the kind of job they want or why they're qualified. When people do come to an interview prepared to make a cohesive case for themselves, they stand out sharply. Think of a resume as a script that organizes your thinking, so when you're asked a question you don't find yourself stumbling around looking for the right response.

Before you write anything down, think about what you have to offer and how those skills and experiences can be presented in terms of what the job requires. Start by doing some research on the market (and yourself).

- *What kinds of skills and experiences are required?*

- *What can you say that demonstrates that you have made some effort to learn about the company or organization?*

- *What can you tell them about the contribution you're qualified to make?*

Research can also mean finding a person to help get you in the door. The executive recruitment firm Russell Reynolds estimates that 70 percent of jobs are landed through personal contacts.

Dear Charlie:
Attached is the resume of someone I think you should meet.

A resume is frequently the first detailed information about you that a potential employer will receive. It is the first impression of you. Not the final impression—that is *you.*

What's Important in a Resume

A resume summarizes the facts about you, your education, and your experience that are relevant to the job you want. But the most important point is that it positions you in the mind of the reader or interviewer.

Summarize what you have to offer (or what you want)

The single most important section is a heading that summarizes what you have to offer a prospective employer in terms of experience, skills, results or interests, or your job objective. Don't be a pessimist and conclude right away that you don't have the qualifications. Most people have more than they realize, but an amazing number either can't pull them together in coherent form or are too lazy to think about how they relate to the person receiving the application.

Put the summary at the head of your resume, in boldface type.

14 years of marketing experience, proven ability in building brands

Information technology officer with track record in Business Process Reengineering

Objective—management training position in retailing

Think about this summary more than anything else that follows. Work on it, distill it.

Make it as easy as possible for a potential employer to decide whether you might be a candidate for the job at hand—and whether it is worthwhile to go to the next step and invite you to an interview. Remember: The purpose is an interview, not a place in a file drawer.

Keep it simple

Stick to standard, conventional forms. A prospective employer, confronted by a pile of applications, will not be charmed by those that must be figured out like a puzzle.

No fancy formats or pop-ups. A standard $8\frac{1}{2}$ by 11-inch page, designed to go in a standard Number 10 business envelope, and a standard file folder, easy to find for further reference, is the *only* professional style. Make it neat and not fussy. Avoid lots of italics and boldface, special typefaces, colored paper. Resumes on videotape are seldom acceptable except in companies where show biz is in style.

A resume should be straightforward, logical and truthful. Make it easy for the reader to understand you and to track your career. And write it yourself. No professional consultant knows you as well as you do, nor cares as much about getting you a job.

Keep it short. Try to get your resume on one page, two at the most. If you have little experience, padding won't help. If you have decades, all the more impressive to stick to highlights. Don't forget that there will be a cover letter—and an interview—in which you can elaborate on any points you want to stress.

What to Put In—What to Leave Out

Leave out the small stuff and the old stuff, so you can fully make the points that are *important*. You don't have to put everything in a resume; keep back something for the interview. Leave out those high school awards, the college fraternity social chairman, the minor achievements. Leave out "References available on request"—if we want them, we'll ask for them. Put in everything that points to why you would be good at the job.

Make sure you have described your accomplishments in terms of the result, not the activity. It is important for your reader to know how far you moved the rock, not how much time you spent pushing it.

There's no one perfect style for everybody. The resume represents *you*, and you're not like everybody else. One useful format is to divide it into two parts—a tight chronology of your jobs and responsibilities, followed by a page highlighting your significant achievements.

Start by putting in everything; then boil it down to a page or so by cutting the marginal points or those that barely apply. If they don't directly make the case for your candidacy, take them out or cut them down. Stick to the facts, and be specific.

People put the strangest things in their resumes. The test of what to include is the same as it is for anything else you write: Is it relevant? Is it true?

Here are some other basics:

What to put in

- First things first. Name, address, phone number at the top. Also fax and e-mail.

- State a job objective—factually, without embellishment. A prospective employer doesn't care if you want a "challenging position." (Sometimes we think we would hire, sight unseen, anybody who would be willing to get out all that nonchallenging work every day.)

- Some people are qualified to pursue alternative careers—in either law or finance, for example. If that's you, prepare two different resumes—one for each objective, with the balance of the resume tailored to that objective.

- List jobs, including locations and dates—starting with the most recent.

- An employer is more interested in what you have been doing lately than in what you did ten years ago. If you gained your most relevant experience some years ago on an earlier job, make it stand out by the amount of detail in the resume—not by changing the order.

- If you've been out of work at some point in your career, or worked for companies that no longer exist, you may be tempted to omit those experiences. Resist the temptation. Fill in all the gaps; otherwise, it looks as though you're hiding something. For the period you've been out of work, simply say something like "1997–99 Personal Projects," or whatever happens to be the truth.

- Include some definition of the size of the business you worked in, such as sales, unless the size will be obvious to all readers. Describe the scope of your responsibilities and, most important, *your* accomplishments. Be honest; if you were part of a team, say so. Don't exaggerate.

- Include all college or graduate degrees and dates. Leave out high school (unless you're applying for a first job or attended an unusual school).

- List any boards of directors you serve on, professional or trade associations, or significant community or volunteer service organizations, with the most important ones first.

- List any published articles or books.

- If you are fresh out of college or graduate school, extracurricular activities can be relevant.

- Briefly cover significant personal facts. *Briefly*. List all special skills, such as technology skills or facility in a foreign language. The nature and degree of your computer savvy can be important in many jobs nowadays. You never know when such secondary abilities will be the deciding factor in getting you an interview, or even a job.

What to leave out

- *Age or gender*—not essential, seldom relevant, and the law says you cannot be asked. But, of course, prospective employers will figure out whether you're male or female, and will get a pretty good idea of your age from the dates on your resume.

- *Honors or prizes*—unless they are genuinely important in your field.

- *Height and weight*—unless it is relevant to the requirements of the job.

- *Travel*—unless relevant.

- *Salary requirement*—if appropriate, put this in the cover letter.

- *Hobbies*—who cares?

- *Race or religion*—best left out. The law says you cannot be asked.

- *Clubs*—not necessary.

- *Photograph*—only beginners seem to include their pictures.

Make it perfect—make it professional. No typos. No misspellings. A small typo will detract from an otherwise stellar resume. It comes off as unprofessional and careless, and sends the wrong signals. You don't have to go to the expense of printing your resume, but get top-quality reproduction (laser or high-quality inkjet prints). Crisp and black, without smudges.

Be careful with abbreviations; people may not know what they mean. Give the full names of companies, trade associations, governmental bodies.

Take out all unnecessary words. Shorten everything to the extent of writing in telegraphic style—without verbs, articles, or connectives. Write in the third person: "Managed sixty-four-person department," not "I managed . . . "

Then show it to someone who will bring a fresh perspective and who knows you well enough to ask "Is this really what you wanted to say?" "Is this relevant?" or "So what?"

The Letter That Gets Your Resume Read

Never send a resume without a covering letter. It takes time to go through a resume. Employers decide from your covering letter whether your resume is worth that time—and might ultimately lead to an interview.

Your letter is your opportunity to focus on the chief attributes you want to fix in your reader's mind. It's worth putting thought into what you say in your letter, and taking care with how you say it.

Here are some points to keep in mind:

1. Think about the reader

What can you offer that will benefit the prospective employer? Do you have relevant experience, training, or education?

Consulting with a young law student, we were struck by his draft letter applying for a job in the Environmental Protection Agency. Almost every paragraph started with "I," as it outlined his impressive credentials. A better letter—starting with the needs of the reader rather than the virtues of the writer—began by stating:

> *According to press reports, your agency is under enormous pressure in staff and budgets, and it is obvious that you must have people who can move fast and carry a heavy load. Here are several reasons why my background should be helpful to EPA in exactly those ways.*

Try to single out a benefit to the organization that will accrue from your joining it.

2. Identify the sort of job you're looking for

State it clearly and at once. Say what led you to apply—a want ad, a recommendation from a friend, the reputation of the firm.

A letter applying for a job as a research analyst started in this mysterious way:

> *Dear Mr. Ball:*
> *It's spring already—a time to think about planting seeds. Some seeds are small, like apple seeds. Others are bigger. Coconuts, for example. But big or little, a seed can grow or flourish if it's planted in proper soil.*

The applicant would have done better to start like this:

> *Dear Mr. Ball:*
> *I understand that you are looking for a research analyst.*

Better straight to the point, however trite, than roundabout, however ingenious. Mr. Ball wants to know what the letter is about; he doesn't have time to play guessing games.

Here's a direct approach that led to a job:

> *This letter is in response to a recent conversation with Mary Brown, in which Mary suggested that my background in continuous process improvement might be a good fit with your current needs.*
>
> *In my current position as Consulting Quality Leader / Master Black Belt at General Equipment Systems, I am responsible for using my process improvement and team facilitation skills to support a wide variety of quality projects.*

Don't emulate the fellow who had his tonsils removed through his belly button, just to be different.

3. Pique the interest of the reader

You can often get to the point in a way that adds an extra element of interest.

According to the grapevine, you've been looking for an experienced research analyst for three months. If so, then it's strange that in such a small community we didn't know each other until now.

That is not the same as trying to attract favorable attention by buttering up a potential employer, which doesn't work:

I have long admired your firm as one of the most reputable and professional in the country. It is clear that your success cannot be attributed to accident or coincidence.

Flattery may still have its uses in business, but introducing yourself as a flatterer won't impress most employers.

Here are two openings that go straight to the point in interesting ways:

Dear Ms. Page:
Do you need an exceptionally fast accountant? If so, I may be your man.

Dear Mr. Kilgour:
Our mutual friend Charles Hartigan has urged me to write to you about your plan to create a publicity department. I would like to help you set it up—and I know how to do it, as you can see from my resume.

4. Address an individual, never a title by itself

Don't address your envelope *Attention—Personnel Director*, or *Manager* or *Head of Accounting Department*.

We threw out applications addressed only to *Creative Director* or *Chairman* on the ground that if the writer were too lazy to find out a person's name, he or she would be too lazy to do a good job.

Spell all names right. It is astonishing how often job applicants misspell names, including the names of the firms they want to work for. A message comes through even before the letter is read: "This applicant can't be seriously interested in working here."

Check and double check all names, even those you think you know. Are you sure it's "Field" and not "Fields"? How many "f's" are there in "Hefner"? Does Eliot spell his name with one "l" or two, one "t" or two? Is it "Ann" or "Anne"? "Proctor" or "Procter"?

5. Be specific and factual

Once you've made clear what job you want, then touch on your chief qualification. Avoid egotistical abstractions such as:

Ambition mixed with striving for excellence is one of my strongest assets.

Ask yourself how you would feel saying that to a prospective employer. If it would embarrass you in person, don't put it in writing.

So how do you indicate personal characteristics that may be among your most important qualifications? Be specific. Offer evidence in support of any claim of ability, and put the evidence factually.

My experience includes such activities as:

Utilizing continuous process improvement methodologies and quality tools in the redesign of company processes to reduce defect conditions and increase profitability

Working closely with departments to identify opportunities for process improvements

Coaching/mentoring teams in the use of quality tools such as Pareto charts, Fishbone diagrams, Scatter diagrams, Regression analysis, Designed Experiments, and others

Establishing control charts to help business leaders accurately assess both the stability of their processes and the ability of these processes to meet customer requirements

Designing a process management system that will allow the business leaders to understand and manage their respective departments as a series of interrelated processes

Additional details are included in the accompanying resume.

Touch on your most important accomplishments in the same matter-of-fact style. Cover your pertinent responsibilities. Never brag, but don't hesitate to cite authentic evidence of your value. If you don't blow your own horn, who will?

6. Be personal, direct, and natural

You are a human being writing to another human being. Neither of you is an institution. Be businesslike and courteous, but not stiff and impersonal.

The more your letter sounds like you, the more it will stand apart from the letters of your competitors. But don't try to dazzle the reader with your sparkling personality. You

wouldn't show off in an interview, so why show off in a letter? If you make each sentence sound the way you would say it across a desk, there will be plenty of personality in your letter.

Most good covering letters make their point in about a half page; few run longer than a page. If your cover letter looks more formidable than your resume, you have defeated your purpose.

Keep it short.

7. Propose a specific next step

You will be writing to a person or to a box number. In either case, close the letter with a clear and precise statement of how you wish to proceed toward an interview—remember that's your objective, not a "We'll keep your letter on file" response.

Avoid such mumblings as:

Hoping to hear from you soon.

Thank you for your time and consideration.

I'm looking forward to the opportunity of discussing a position with you.

All such conclusions place the burden of the next step on your busy prospective employer. Why make someone else work on your behalf? Do the job yourself.

I'll call your office Wednesday afternoon to see if you'd like me to come in for an interview.

I'm free for an interview every morning until eight forty-five and Thursdays after two-thirty. I'll call your office Tuesday afternoon to find out if you'd like to get together at any of these times.

At this stage you should volunteer to telephone. A phone call now makes things easy for the person at the other end. If you don't call, then someone has to go to the trouble of calling or writing you.

Or you could end your letter like this:

If you'd like me to come in for an interview, you can reach me at (999) 438–6688, extension 276, from 10 A.M. to 1 P.M., and from 2 P.M. to 6:30 P.M. on working days. I can arrange to get away for a couple of hours any day but Monday; best for me would be Thursday morning.

The idea is to make it as simple as you possibly can for your prospective employer to set up a mutually convenient appointment.

8. Send different letters to different readers

With the exception of the cases noted in our earlier discussion of the resume, you will probably want to send the same resume to all potential employers. But you may not want to approach all of them exactly the same way in your covering letter.

Certain of your qualifications may be more important to one employer than to another. Take the trouble to tailor your letter for each of them.

Send lots of letters. Finding the right job in the shortest time is in part a numbers game. Send your letter and resume to as many different people in an organization as you can; it is impossible to predict where the opportunities lie. And mail to lots of companies. The more people who see your resume, the greater the odds that one of them will have an open job and invite you to come in for an interview.

Send a second letter if you haven't had a response after a few weeks. It's possible that the addressee was traveling, that your application was mistakenly screened out and never seen, that it was forgotten, or that a job has opened up that wasn't there when you first wrote.

9. Follow up an interview in writing

You will stand out from most other candidates by the simple act of sending a follow-up note confirming your interest and expressing appreciation for the interview. So few people do it that it will put you high on the interviewer's list, at least in terms of interest and courtesy.

Try to find something specific to comment on, something beyond a perfunctory "thank you."

Dear Ms. Oldham:

After I left your office, I realized that we'd talked for more than an hour. It was stimulating—and made the job seem most attractive.

You mentioned your need for someone who truly understands the consumer. I hope you'll keep in mind that I spent three years selling stoves door-to-door plus five years in a research firm. I figure that I've spent five thousand hours talking person-to-person with some three thousand consumers in twenty states.

Whatever you say, don't gush or grovel. Don't exaggerate your appreciation for the interview or your interest in the job. Here, as in everything you write, candor and sincerity will serve you best.

If you don't get the job, don't give up—especially when you feel you've made a favorable impression. Find ways to

stay in touch with anybody who already thinks well of you. A
letter from time to time can make sure you come to mind in
case a suitable job opens up, or in case your interviewer hears
of one in another company. You might fire off an occasional
clipping on some subject of mutual interest, accompanied by
a brief note. You could report on some activity that's new
since the interview and bears on the line of work you're look-
ing for. Or you can simply reaffirm your interest.

If nothing works, maybe what you need is more relevant
training or other experience. A sign in a college placement
office said:

> **YOUR RESUME IS FINE**
>
> **(Change Your Life!)**

When Michael Capellas was elected CEO of Compaq, he
noted that he had never written a resume in his career. The
best way to get a better job is to do a great job where you are.

The E-Resume

"Digital resumes, digital employment advertising, digital resume searches—it's a rebuilding of the infrastructure," says Intel Chairman Andy Grove.

No resumes were mailed by Jason Spero, who got his interview at RealNames in California by distributing his resume via Web site, targeted e-mail, and listing on the school's on-line resume directory service.

After an initial meeting, it was all e-mail correspondence leading to a job. "An e-mail is less threatening than a phone call," says Spero. "The person is not feeling like, 'Oh, God, he is going to keep calling me, and I don't have caller ID.' I was never more threatening than a line item on a computer."

Nearly half the Global 500 companies are actively recruiting on the Net, reports *Fortune*. At least 28,500 job boards list opportunities. Software programs write your resume and provide interview coaching. Compaq receives 85 percent of its resumes electronically. And it's not all techies—two thirds of on-line job seekers come from nontechnical professions, says an industry newsletter.

"One of the big equalizers of the Internet is that it has allowed small companies to have exposure," says another successful job seeker. "In the old world, you would never even

see these companies. I never would have been able to hook up with a startup like this, and it's such a perfect fit."

While it's still early days for this new recruiting medium, it's not too early to take note of its implications for electronic resumes. They must be easily read and scanned for key words. Optical scanners catalog, sort, store, and access resumes, and search for specifics—names of software programs the applicant has mastered, for example, not generalities like "familiar with all relevant software programs." Electronic searches work best with plain vanilla text and no boldface, italics, underlines, or fancy type fonts (use Ariel or Times Roman). Avoid bullets, dashes, or similar nonletter, non-numeric symbols—they confuse scanners.

It is especially important to have a clear objective. "You only have half a screen to impress a recruiter," notes a job-search expert. "They don't want to scroll down to find out what you want to do."

***The resume on the following page, with e-mail
follow-up, helped land an e-job.***

*The objective was a job in the on-line world, so this resume
appropriately lists URL and e-mail addresses (plus phone num-
ber and mail address).*

The resume tells an impressive story and tells it clearly.

*It starts with the most recent experience, business school, citing
both academic and leadership achievements.*

*It shows two impressive summer jobs, describing accomplishments
as well as activities.*

*It shows purpose—choosing a technology brand name (Microsoft)
for a job, then leaving the Internet world to go to business school,
before returning to a software company.*

*There's just enough personal information to show the candidate
has broad interests.*

And it does it on one page.

*We might have preferred to start with a heading of relevant expe-
rience or objectives (OBJECTIVE: PRODUCT MANAGE-
MENT POSITION WITH AN INTERNET COMPANY),
but our advice is general, not a formula—and this one worked.*

JASON SPERO
[address, telephone, e-mail, URL]

EDUCATION

1997–present **J. L. KELLOGG GRADUATE SCHOOL OF MANAGEMENT
NORTHWESTERN UNIVERSITY** Evanston, Ill.
Candidate for Master of Management Degree, June 1999,
Dean's List
- Majors in management and strategy, entrepreneurship
 and marketing
- Chair of High Tech Club (200 members, $15,000
 annual budget)
- Chair of Soccer Club (100 members, $10,000 annual
 budget)

1990–1994 **AMHERST COLLEGE** Amherst, Mass.
Bachelor of Arts in political science, May 1994
[List of undergraduate sports activities and awards]

EXPERIENCE

1998 **MICROSOFT CORPORATION** Redmond, Wash.
Product Manager Intern,
Windows NT Server 5.0 Group
- Built independent software vendor (ISV) Partners
 Program for Windows NT Server 5.0.
[List of specific program elements]
- Developed long term marketing plan for ISV strategic
 partnerships for Windows NT launch.
- Authored and managed primary market research
 campaign for use in developing positioning strategies
 for Windows NT 5.0 launch.

DONALDSON, LUFKIN & JENRETTE, INC. New York, N.Y.
1997 Associate, Investment Banking Division
[List of responsibilities and accomplishments]
1994–1997 Analyst, Investment Banking Division
[List of responsibilities and accomplishments]

PERSONAL

Alumni Fund-raising Agent for Amherst Class of 1994.
Youth soccer coach.
Enjoy travel, black Labradors, wine, basketball, soccer
and scuba.
Traveled extensively in Spain and Italy. Learning
harmonica.

12 Editing Yourself

Never send out the first draft of anything important. Good writers consider editing an essential part of the writing process, not just a final perfectionist polishing. The great songwriter Jerome Kern struggled to perfect his wonderfully smooth melodies; his collaborator Oscar Hammerstein II described the process: "Smoothness is achieved only by scraping off roughness. None of his melodies was born smooth."

Nothing you write will be born smooth either. Edit to scrape off roughness. Edit to:

Shorten
Sharpen and clarify
Simplify
Check for accuracy and precision
Improve order and logic
Make sure nothing is left out
Review tone
Improve appearance
Examine everything from the reader's point of view

The first rule: If it isn't essential, cut it out. Go through your draft once asking only this question: *What can I get rid of?* Cut unnecessary words, phrases, sentences, paragraphs. Mark Twain said that writers should strike out every third word on principle: "You have no idea what vigor it adds to style."

Twain's advice works especially well in e-mail—your message pops. Before you hit Send, try Delete.

The first time we wrote the above paragraph—before editing, it was more than twice as long (and not as communicative).

Go through your draft a second time with these questions in mind:

1. Are you mumbling?

In putting together a rough draft, it speeds things up to get *something* down, even if it only approximates what you want to say. But never settle for a rough approximation in your final draft. Have you chosen the verbs and adjectives that express your meaning precisely? Could you be less abstract and more down-to-earth? Scrutinize every important thought.

2. Have you got things in the best order?

This point originally came later in the chapter. In editing, we decided it was second in importance—and closely related to the point that follows.

Good writers shift things around a lot. This used to be a laborious business calling for scissors and Scotch tape and a lot of patience. With Cut and Paste in word processing you can take your work apart and reassemble it in seconds.

Many good writers print out a hard copy of each draft, to make it easy to compare a revised version against an earlier one. It is not unusual to decide that some of your shifts of order aren't improvements after all.

3. Are there any holes in your argument?

Put yourself in your reader's shoes. Does everything follow logically? Don't expect your reader to leap from point to point like a goat on a rocky hillside. Make sure your trail is clear, smooth, and well marked.

4. Are your facts right?

Check all statistics and statements of fact. A single bad error can undermine your reader's confidence in your paper. In particular, check quotations. "I quote a lot," says an erudite author. "I always check, even when I am in no doubt. And I am *always* wrong."

5. Is the tone right?

Too stiff? Too chummy? Lacking in sympathy? Rude? Again put yourself in your reader's place and change anything you, as a reader, might find offensive.

From First Draft to Second: An Example

Here are five instances, taken from a single paper, of how editing shortened, sharpened, and clarified what the writer was trying to say:

First draft	Second draft
Consumer perception of the brand changed very positively.	*The opinion of consumers improved.*
Generate promotion interest through high levels of advertising spending.	*Advertise heavily to build interest in promotions.*
Move from product advertising to an educational campaign, one that would instruct viewers on such things as . . .	*Move from product advertising to an educational campaign on subjects like . . .*
Using the resources of our organization in Europe, in addition to our Chicago office, we have been able to provide management with alternatives they had previously been unaware of.	*Our offices in Europe and Chicago produced alternatives that management hadn't known about.*
Based on their small budget, we have developed a media plan which is based on efficiency in reaching the target audience.	*We developed a media plan that increases the efficiency of their small budget by focusing on prospects.*

Two Simple Editing Tips

No matter how good an editor you are already, you will become better if you follow these two practices:

Let time elapse between drafts.

Solicit the opinion of other people.

Print a clean copy of your draft. Set it aside. Get away from it at least overnight. Then come back to it in the morning. You'll see it with new eyes. Imperfections that were invisible the day before will now pop out at you. Through some alchemy of time, you'll know what to do about them.

When you ask for comments from other people—colleagues, friends, anybody whose opinion you respect—you're putting them to work for you. If somebody's suggestions are helpful, say "Thank you" and use them. If you disagree with them, say "Thank you" and don't use them. No need to argue or prove your consultant wrong. It's your work and you are making the decisions. You'll find that nearly everybody will spot *something* you overlooked. It can be valuable just to discover a single point that isn't clear.

The late David Ogilvy sent drafts of all important papers to several of his associates with the handwritten injunction: *Please Improve.* He was the beneficiary of so many improvements that he lived his last twenty-five years in a sixty-room castle in France.

Editing improved nearly every page of the book you're reading:

9/20/99

Chapter 5

E-MAIL – THE GREAT MAILBOX IN THE SKY

There was Santa on the stage of New York's Radio City Music Hall, reading Christmas letters and without making anything special of it, telling thousands of kids and grownups they can reach him at *Santa.com.* And nobody blinked! We've moved from Baby Boomers to Generation X to *generation.com.*

~~There's a larger gap between snail mail and e-mail, and it's growing fast.~~ The U.S. Post Office counts its mail in hundreds of billions; e-messages are counted in trillions, and almost doubling each year.

E-mail does things that letters or phone calls cannot do as well, or cannot do at all. It is easy, fast, simple – and cheap. It's perfect for quick answers, confirming plans and short messages. It saves money on phone calls, messengers and airfreight bills.

With e-mail, ~~phone tag~~ *time zones,* ~~goes~~ away. As do ~~time zones. Send at your convenience, the receiver picks up at his or hers. And~~ *es phone tag.* If you do connect on the phone, you are likely to be interrupting whatever the other person is doing, even if it's just thinking. ~~By contrast, e-mail is civilized.~~

[margin note: *— Message to*]

[margin note: *With e-mail, you send at your convenience, t receiver pi up at his hers*]

E-mail helps organizations stay connected and react quickly.

> *All interoffice communications should flow over e-mail, preaches Bill Gates, "so workers can act on news with reflex-like speed." He goes on to direct that meetings should not be used to present information: "It's more effective to use e-mail".*

[margin note: *Roman*]

A *generation.com* type also cites the benefit of a "permanent" address: "Physical residence for people my generation changes constantly, but my e-mail address will stay with me forever so people will always be able to communicate with me."

~~E-mail is easy. Too easy sometimes.~~ Its emphasis on speed ~~takes away from~~ *conflicts with* matters that deserve thought and reflection. There are times when nothing beats conversation to solve a problem, or when courtesy calls for a nicely typed or handwritten letter.

[margin note: *Ital*]

Warning: e-mail can be addictive and create problems of its own. Newcomers on-line are so giddy with their discovery they want to broadcast it to everyone. Garrulous bores find a large unwilling audience. Managers with a natural tendency to hide barricade themselves behind walls of e-mail, sending notes to people four desks away. More

13 **Making It Easy to Read**

If what you've written looks formidable or messy, your reader braces for an ordeal before reading a word. "This will be heavy going" is the message you deliver, in a glance.

If what you've written *looks* easy to take in and get through, you're off to a good start. That was always true with printed documents, now even more so with e-mail. When a message runs more than a few lines, formatting becomes an issue. Full-screen paragraphs are almost impossible to read and show little consideration of the reader (as well as lack of organized thinking by the sender).

Most word processing programs allow you to preview the appearance of entire pages. This gives you a better sense of how your document looks than partial pages on a screen, and can help you decide what improvements may be called for. And the word processor's virtuosity in formatting makes it easy to put those improvements into effect.

Here are some ways to make everything you write look *professional*—inviting to read, easy to understand, and simple to refer to.

1. Start with a heading

Put it top center in capital letters. This orients your reader at once.

<div align="center">

OFFICE CLOSES FRIDAY NOON

WE WON THE BUSINESS

</div>

2. Keep paragraphs short

Wherever you see a long paragraph, break it into two or more short ones. This is particularly helpful with e-mail.

3. Use typographic devices for clarity and emphasis

Most readable magazines and newspapers prefer *italics* to <u>underlining</u> for emphasis.

> *To stress key ideas, put them into indented paragraphs. This emphasizes them by setting them apart. Italics can add even greater emphasis.*

When you do use underlining—in headings, for instance, or lead-ins—use a <u>single continuous underline</u> rather than a <u>choppy</u>-<u>looking</u> <u>underline</u>, <u>one</u> <u>word</u> <u>at</u> <u>a</u> <u>time</u>, which slows reading.

While color and special fonts on your PC add emphasis, they don't come across as businesslike in documents. A judicious use of color can be effective in decks and other visual presentations (if not overdone).

4. Numbered, lettered, or bulleted points help your reader follow your thinking

These devices look best a couple of spaces to the left of the text margin, like the a. and b. that follow.

 a. Word processors put tools into your hands that used to be available only to printers. Boldface type, for example, can make it easy for your reader to scan your main points. (We use it for that purpose throughout this book.)

 b. "Hanging" your letters and numbers in the margin makes your divisions and subdivisions easier to follow.

5. Use uppercase and lowercase.

All-capital words and phrases should be used with restraint, except for headings. Printing text in all capitals, characterized in the e-world as SHOUTING, works against readership. There is a place for their sparing, occasional use—for a blast of emphasis, as Bill Gates used them in a note to his colleagues at Microsoft:

 "I am hard-core about NOT supporting" [the latest version of Java from Sun Microsystems.]

6. Break up large masses of type

Use subheads, like the numbered points throughout this book. Type them in capitals and lowercase, underline them or put them in boldface, and leave plenty of space above and below.

It often helps to send long e-mail messages as attachments. If that's the case, say so immediately: "Here's an attachment." And make the attachment easy to transmit and easy to read. It's

irritating to receive presentations via e-mail with wild colors for text and background. They're hard to read, sometimes impossible, and take forever to download.

7. Use space to separate paragraphs

It looks neater than indents.

Use single spacing between lines, double spacing between paragraphs. Drafts of documents for which you are soliciting comments should be triple-spaced throughout, with extra-wide margins. It makes editing easier.

8. Handle numbers consistently

Newspapers generally spell out numbers ten and under, and use numerals for 11 and up. Book publishers follow other rules. Whatever you do, be consistent.

It is easier to grasp big numbers when you write $60 million rather than $60,000,000.

9. Make charts easy to handle—and interesting

If your document includes wide charts, don't make the reader turn it sideways to read them. Use horizontal foldouts.

Consider whether your charts need to be in the body of your document at all. Might they go at the end, as appendixes? Your document will look less formidable if it is uninterrupted by graphs and charts. If you do use charts, color adds variety and interest.

Number your appendices and separate them clearly with tabs. This makes them easy to find.

10. Number your pages, even in early drafts

If inserted material messes up the numerical order, use 1A, 1B (in handwriting, if necessary), and so on. Nothing is more annoying than trying to find a particular passage in an unnumbered document.

Before printing your final draft, run your eye over it with these techniques in mind. What can you do to make it look more interesting? Where will your meaning be illuminated by subheadings, italics, boldface, indents, underlines, enumeration? Write for the eye as well as the mind.

Legalese—and Hard to Penetrate

(We didn't make this up. This is precisely how it came.)

RESOLVED, that this Committee hereby: (1) approves (a) the compensation for the Officers of the Corporation for its fiscal year 2000; (b) the total award for the fiscal year 1999 performance under the Corporation's Annual Performance Plan (the "APP"); (c) (i) the grants of Nonqualified Stock Options and Restricted Shares under the Corporation's Long-Term Incentive Plan (the "LTIP"), and (ii) the grants of the Corporation's Common Shares and the corresponding payments of "gross-up" compensation to account for the tax on such grants, all the foregoing grants and payments to be effective as of the next Valuation Date and at the Fair Market Value determined as of such Valuation Date, all such terms as defined in the LTIP; and (d) the revision beginning with fiscal year 2000 of the Performance Factors and Bonus Factors in Attachment 1 to the APP; (2) recommends to the Board of Directors the compensation and grants of Nonqualified Stock Options for the Corporation's Chief Executive Officer, all of the actions referenced in clauses (1) and (2) above as shown in Exhibits 1 to 6 presented to and filed with the minutes of this meeting; and (3) authorizes the Corporation's Executive Committee to make, with respect to participants in the APP who are not Officers of the Corporation, any further awards or adjustments in awards under the APP, provided that the sum of all such awards and the individual awards approved in accordance herewith do not exceed the total award approved herein.

Still Legalese—but Possible to Grasp the Gist of It

(Not a word changed)

RESOLVED, that this Committee hereby:

Approves

1. The compensation for the Officers of the Corporation for its fiscal year 2000;

2. The total award for the fiscal year 1999 performance under the Corporation's Annual Performance Plan (the "APP");

3. The grants of Nonqualified Stock Options and Restricted Shares under the Corporation's Long-Term Incentive Plan (the "LTIP") and the grants of the Corporation's Common Shares and the corresponding payments of "gross-up" compensation to account for the tax on such grants, all the foregoing grants and payments to be effective as of the next Valuation Date and at the Fair Market Value determined as of such Valuation Date, all such terms as defined in the LTIP; and

4. The revision beginning with fiscal year 2000 of the Performance Factors and Bonus Factors in Attachment 1 to the APP;

Recommends to the Board of Directors:

1. The compensation and grants of Nonqualified Stock Options for the Corporation's Chief Executive Officer,

2. All of the actions referenced in clauses (1) and (2) above as shown in Exhibits 1 to 6 presented to and filed with the minutes of this meeting; and

Authorizes the Corporation's Executive Committee to make, with respect to participants in the APP who are not Officers of the Corporation, any further awards or adjustments in awards under the APP, provided that the sum of all such awards and the individual awards approved in accordance herewith do not exceed the total award approved herein.

Other Books That Will Help You Write Better

Most people who write well read a lot. They read many kinds of good writing, past and current. Good fiction, good essays, good history, good journalism. Reading gets the shapes and rhythms of good writing into your head.

The best of today's newspaper columnists—among them Thomas Friedman, Maureen Dowd, and George Will—serve up regular examples of how to express a point of view persuasively in limited space. In addition to syndicated columnists, you'll find a variety of good writing every day on the Op Ed pages of major newspapers. Most of it is written by people who, like you, don't write for a living. They have learned to put forward their ideas clearly and forcefully in writing that meets the standards of the top editors.

Reading good writing will help you more than reading *about* good writing, and it's a lot more fun. There are, however, dozens of books that have helped people become better writers. Here are a few we've found especially useful. Some are out of print, and you may have to chase them down by using an on-line book service.

The Elements of Style (Allyn & Bacon), William Strunk Jr. and E. B. White. The new Fourth Edition of this compact classic has a foreword by Roger Angell (and, bless them, an index). "Buy it, study it, enjoy it. It's as timeless as a book can be in our age of volubility" is the endorsement by the *New York Times*.

On Writing Well (HarperCollins), William Zinsser. More for professional writers, but full of useful wisdom.

Simply Speaking (HarperCollins), Peggy Noonan. Advice from a terrific speechwriter.

Lend Me Your Ears: Great Speeches in History (W. W. Norton), Selected by William Safire—also an outstanding speechwriter, columnist, and student of current language.

Words Fail Me (Harcourt Brace), Patricia T. O'Conner. Guidance from a former copy editor at the *New York Times*, with particularly useful chapters on how to handle numbers and what to do when you're stuck.

Successful Direct Marketing Methods (Crain Books), Bob Stone. Still the most respected text in its field.

The Minto Pyramid Principle (Minto Publishing), Barbara Minto. The comprehensive guide to logic in writing, thinking, and problem solving.

Merriam-Webster Collegiate Dictionary, 10th ed. There are many good dictionaries. This is the only desk-sized one we could find that has both of two useful features: It draws distinctions between similar words (like humor, wit, comedy, farce, burlesque, travesty) and it discusses puzzling matters of usage (such as "which" vs. "that").

How to Write for Development (Council for the Advancement and Support of Education), Henry T. Gayley. A classic that

includes contemporary techniques, but with the same continuing message: "Potential donors respond best to a well-stated case expressed in simple, clear language."

Guide to Proposal Writing (Foundation Center), Jane C. Geever and Patricia McNeill. Steps for successful proposal writing to corporations and foundations.

Say It with Charts (McGraw-Hill), Gene Zelazny. Advice on how to think about charts, and how to choose the kind of chart that's most appropriate for your message.

The Economist Style Guide. Includes admonitions that apply to everyday business writing as well as to the professionals on *The Economist* staff, such as:

> *The first requirement of* The Economist *is that it should be readily understandable. Clarity of writing usually follows clarity of thought. So think what you want to say, then say it as simply as possible.*
>
> *Use the language of everyday speech, not that of spokesmen, lawyers, or bureaucrats.*
>
> *Do not be hectoring or arrogant. Those who disagree with you are not necessarily stupid or insane. Nobody needs to be described as silly: Let your analysis prove that he is.*
>
> *Don't boast of your own cleverness by telling readers you correctly predicted something or that you have a scoop. You are more likely to bore or irritate than to impress them. . . .*

The introduction to the latest edition affirms the importance of good writing:

> *On only two scores can* The Economist *outdo its rivals consistently. One is the quality of its analysis. The other is the quality of its writing.*

Amen.

About the Authors

The authors worked together at Ogilvy & Mather Worldwide, a major advertising agency noted for its interest in good writing. They have left the advertising business but rejoin on projects like this.

KENNETH ROMAN, a former chairman and CEO of Ogilvy, is active on corporate and nonprofit boards, where he sees lots of business writing—and its abuse. He is also the coauthor of *How to Advertise*.

JOEL RAPHAELSON, a former Executive Creative Director at Ogilvy, is mostly retired but rouses himself from time to time to write about writing and other subjects.

The authors also worked together on *The Unpublished David Ogilvy*, edited by Mr. Raphaelson (and abetted by Mr. Roman).